Digital Astrophotography

Stefan Seip

Digital Astrophotography

A Guide to Capturing the Cosmos

Stefan Seip
www.astromeeting.de

Editor: Gerhard Rossbach
Copy Editor: Joan Dixon
Translation: Elke Schulz
Layout and Type: Josef Hegele
Cover Design: Helmut Kraus, www.exclam.de
Printer: Friesens Corporation, Altona, Canada
Printed in Canada

ISBN: 978-1-933952-16-1

1st Edition
© 2008 by Rocky Nook, Inc.
26 West Mission Street, Ste 3
Santa Barbara, CA 93101-2432

www.rockynook.com

First published under the title "Astrofotografie digital"
© 2006, Franckh-Kosmos Verlags-GmbH & Co. KG, Stuttgart, Germany

Library of Congress catalog application submitted

Distributed by O'Reilly Media
1005 Gravenstein Highway North
Sebastopol, CA 95472-2432

Foreword

by Robert Gendler

Astrophotography has witnessed two dramatic changes in the last few decades. The first was the conversion to digital technology, which dramatically altered the process of acquiring images, as well as the techniques of manipulating image data. This digital revolution had a profound impact on the quality of images both at the professional and amateur levels, and succeeded in pushing back the limits of depth, detail, and color that could be achieved in astrophotographs.

The second, more recent, revolution was more gradual and not quite as dramatic, but had an equally powerful impact on astrophotography, particularly at the amateur level. This revolution has to do with the introduction of webcams and the modification of digital SLRs for astronomical imaging. This second revolution is responsible for the huge growth in numbers of those who are now able to participate in astrophotography, by disseminating the tools of astrophotography into the hands of those who might not have the budget to pursue the hobby by traditional means.

With that said, webcam and DSLR astrophotography should not be confused with a lower level of astrophotography. Webcams placed into skillful and experienced hands have produced planetary, lunar, and solar images with unprecedented detail and clarity. DSLR images can have aesthetic results rivaling traditional methods.

Stefan Seip has been at the vanguard of aesthetic astrophotography for many years. He has used CCD cameras, webcams, and DSLRs to produce some of the best astro-images to come out of the amateur realm. I can't think of anyone better to bring the new technologies of astrophotography to those who are eager to learn them. By reading this book anyone can learn the fundamentals of astrophotography so they too can experience the profound joy of photographing our universe.

Robert Gendler
http://www.robgendlerastropics.com
August 2007

Contents

Chapter 1
Before You Start

A World Full of Possibilities

Who isn't familiar with those colorful and intriguing pictures of the universe? They cast a spell on almost every observer and often kindle the desire to try it out oneself.

What This Book Offers You

Observing the night sky is steadily becoming more popular. Looking at the night sky, be it with the naked eye, binoculars, or a telescope, provides us with a sense of the infinite universe and emphasizes its vastness, in which we appear as grains of sand in a huge desert. The view through a telescope is fascinating; however, it is radically different from those colorful images we have all seen. Instead of a lustrous nebula, the eyepiece of the telescope reveals only a small, dimly lit, gray spot. Unlike the eye, a camera can enhance the incoming light allowing a photo to display the full, glorious splendour of a celestial object. This can quickly lead to the desire to take images of the night sky oneself, in order to capture the wealth of colors, forms, and structures that are so abundant in the universe.

Today's digital cameras, which are readily available to amateurs, greatly facilitate the entry into astrophotography and provide appealing results after only a short amount of time. Probably, the biggest advantage of digital

The Orion Nebula (M42): Left, viewed through a telescope – right, photo with a CCD camera.

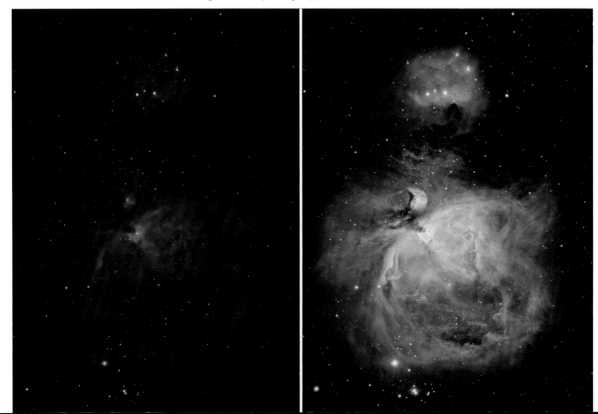

cameras is the possibility to check an image immediately after the exposure, allowing you to spot potential mistakes and instantly correct them. Digital cameras also allow for shorter exposure times than film photography.

The cosmos offers a wide variety of motifs, however, not all camera types are equally suited for every application. Digital compact cameras, webcams, digital single lens reflex cameras (DSLRs), as well as astronomical charge-coupled device (CCD) cameras each have their preferred areas of application and handling. With this book you will learn which camera is best suited for various objects, and the easy-to follow, step-by-step instructions will guide you through the methods to capturing your first successful astrophotos.

In the following four chapters, you can find out what you need to consider and what you can achieve with each camera. To help with this, you can find an overview of the respective exposure data of the astrophotos included in this book on page 152.

But, how do you proceed after the image has been taken? An essential component to successful results is image processing. Simple, easy-to-follow instructions with sample images provide the necessary know-how in this area as well. And, to gain even more practice, you can download the sample files from this book onto your computer at home from the author's website found at http://www.astromeeting.de/astrophotography_digital.htm.

"Image processing" here refers to the necessary enhancement of raw images, which means that all desired information that is contained in the original image data is made visible. However, you need to avoid excessive processing steps, which reveal undesired image details (so-called artifacts) that cannot be found on the exposed celestial object. And do not fall for the widespread misbelief that image processing will help you to get a good image out of a bad exposure. When nothing is there, even image processing cannot elicit a good result,, therefore, the rule applies: the raw image must indeed be good.

The Proper Introduction to Astrophotography

Basic knowledge about the visibility of celestial objects, their apparent magnitude and angular size, their best observation time, the movement of the stars, and how to orient oneself in the sky certainly contribute to taking successful astrophotos. On page 141, you will find the Resources section which includes a selection of books and magazines that are helpful for a general introduction to the hobby of astronomy.

What applies to life in general is also true for astrophotography: One is well advised to begin with relatively simple tasks and proceed to the more difficult ones in the course of time. Fortunately, thanks to digital technology,

Distorted image through excessive image processing.

A digital art image (DigiArt): Here the original images were altered deliberately.

today it is easier than ever to take successful snapshots of the Sun, the Moon, and the planets either right away or after only a small amount of practice. Beautiful results are even possible with rather small telescopes and inexpensive digital cameras. These results provide a prompt sense of achievement and provide motivation to delve further into the realm of astrophotography. However, the requirements concerning the photographer's experience and available technology increase with the smallness of the object (i.e., a long focal length) and its faintness (i.e., long exposure times).

Sun Warning!

When imaging the Sun you must use special solar filters in front of your camera lens or your telescope objective. Looking into the Sun can cause irreversible damage to your vision, even leading to permanent blindness. The absence of filters may also damage your camera irreparably. Do not use solar filters for the eyepiece, but rather use glass or high-strength polymer filters that may also be used for visual purposes, and that can be attached in front of the lens of your telescope or camera.

More advanced astrophotographers may also use an expensive hydrogen-alpha filter, which only allows red light of a narrow bandwith to pass through the filter. With this filter you are able to observe prominences (i.e., the hot gas eruptions of the Sun).

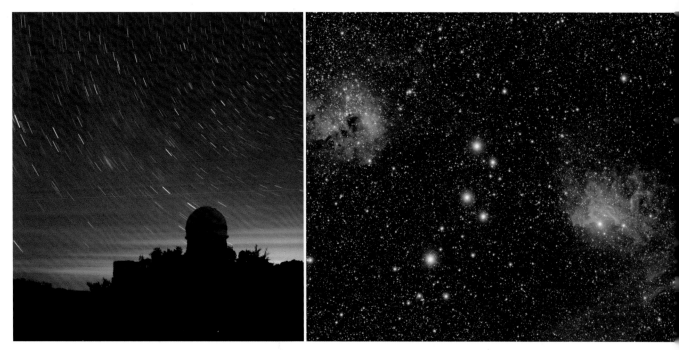

Star trails around the celestial pole, photo with a DSLR.

Region around the Flaming Star Nebula in Auriga (right), photo with a CCD camera.

Thus, photography of faint objects with long focal lengths and a tracked camera requires special know-how and care. In addition, the equipment must also fulfill minimum requirements such as a stout, equatorial mount; a dark site; and a right ascension axis that is accurately aligned with the celestial pole, to ensure capturing pinpoint stars even during longer exposures (see page 7).

Even then, before producing that beautiful astrophoto, you still need to overcome the hurdle of locating faint objects, master the tricky business of finding the right focus with long focal lengths, and check and correct the tracking during the exposure. All these steps must be learned, and thus, the box on page 6 offers a useful path for aspiring astrophotographers. In the process, astrophotography offers everything that constitutes an exciting, ambitious, and long-lasting hobby: quick successes, impressive results, close contact with nature, the handling of technology, and last but not least, new challenges for months and years to come, and for some, even for a lifetime.

Self-built solar filter for the lens with commercially available filter film.

Your Step-by-Step Path to Astrophotography

1. **Scenic Snapshots:** With camera and tripod used for longer exposure times, the camera should be mounted on a tripod and a cable or remote control shutter release should be used.

2. **Piggyback Exposures:** The camera with its lens is mounted piggyback on a tracked telescope. This allows you to take long exposures of constellations and the Milky Way.

3. **Images Through the Telescope Eyepiece:** For cameras without a removable lens this is the only possibility to use the telescope for exposure optics. This method is well suited for detailed images of the Sun and Moon.

4. **A Webcam Through the Telescope:** In this way you can take images of the planets and detailed exposures of the Sun and Moon. Depending upon the circumstances, you might have to use methods that increase the effective focal length of the telescope, such as Barlow lenses or eyepiece projection.

5. **Deep-Sky Images:** Get long exposures of nebulae, star clusters, and galaxies with a DSLR or CCD camera. Combined with these cameras, a telescope acts as a lens with a long focal length. This setup requires telescope tracking to precisely follow the Earth's rotation. Short exposures also allow images of the Sun and Moon.

For Future Reference

Which telescope is the best one to start with, how big is the field of view with my camera, and which focal length should I use? Here, you find answers to these basic questions, which you can come back to any time.

The Appropriate Telescope

To start with astrophotography telescopes with a focal length of 500 to 1000 mm are recommended. If your telescope has a longer focal length, it is better to use a focal length reducer (Shapley lens) initially.

Tracking

To take astrophotos that have a longer exposure time or a longer focal length, it is important to place your telescope on a stout, equatorial mount with a motor-driven tracking system. The tracking system ensures that the telescope follows the apparent movement of the sky due to the Earth's rotation, so that the stars are not trailing during the exposure. For this, the right ascension of your mount must be aligned as accurately as possible with the celestial pole. Some mounts include a built-in polar finder with which a sufficiently accurate and fast alignment is possible.

For the tracking to work accurately the telescope must be balanced in both axes. Keep in mind that if an additional camera is attached to the telescope, a new balancing will be necessary. However, regardless of the accuracy of the tracking, it will not work perfectly over a long period of time: due to mechanical errors and other influences, even long tracked, exposed images will show stars that are not pinpoint. To counteract this influence, the tracking must be checked and corrected during the exposure (i.e., guiding).

Resolution

The resolving power of a telescope is its capability to reveal faint structures, e.g., to show two stars that are close to each other as two separate points. The larger the aperture of a telescope—the higher its resolving power (see table on page 9). It is measured in arcseconds ("); (1" = 1/3600th degree).

Focal Ratio

The ratio between the focal length and the aperture is called focal ratio.

Maximum Exposure Times without Tracking (Region, Celestial Equator)

Focal length		Exposure time
28 mm	approximately	35 seconds
50 mm	approximately	20 seconds
135 mm	approximately	7.5 seconds
300 mm	approximately	3.3 seconds

A telescope with an aperture of 100 mm and a focal length of 800 mm has a focal ratio of 1:8, often abbreviated as f/8. The number corresponds to the aperture stop of a photographic lens. Since it is a fraction, a focal ratio of 1:5 is larger than 1:8. A telescope with 1:5 provides brighter images and allows shorter exposure times. That is why in colloquial usage you will hear f/5 is "faster" than f/8. Customary amateur telescopes have focal ratios between f/4 and f/16. Whereas large focal ratios are well suited for deep-sky photography, large focal lengths (and thus, usually lower focal ratios) are better for planetary photography.

Interaction of Camera and Telescope

Camera Sensor

The light-sensitive element of a digital camera is a sensor that consists of many small picture elements called pixels. Webcams have very small sensors with an edge length of only a few millimeters. Sensors in digital SLRs are about 22 × 15 mm, and digital compact cameras generally have smaller sensors. The sensors of CCD cameras are smaller too, but they cover a wide range, from a few millimeters to the 35mm film format. The size of the individual pixels varies from approximately 5 μm to 25 μm (1 μm = 1 micron = 1/1000 millimeter). The data sheets of high quality digital cameras contain the exact sensor and pixel sizes.

The Correct Angle of View

The angular diameter of astronomical objects is indicated as angular degree or a fraction thereof. With smaller objects, fractions are used whereby one degree is divided into 60 arcminutes (abbreviation ') and each arcminute is again divided into 60 arcseconds (abbreviation ").

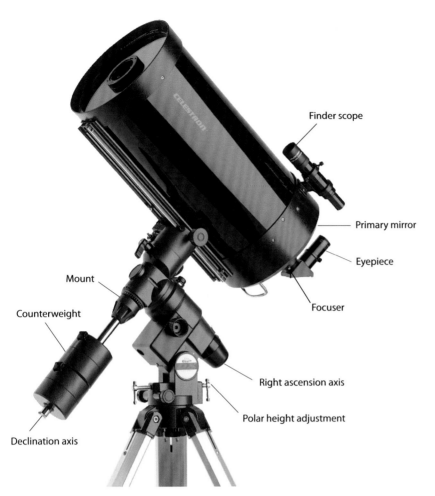

Equatorially Mounted Schmidt-Cassegrain Telescope

Finder scope

Primary mirror

Eyepiece

Mount

Counterweight

Focuser

Right ascension axis

Polar height adjustment

Declination axis

Resolving Power of a Telescope

Aperture	Maximum resolution
60 mm	2.2"
80 mm	1.6"
100 mm	1.3"
130 mm	1"
150 mm	0.9"
200 mm	0.7"
250 mm	0.5"
300 mm	0.4"

Since the celestial objects exhibit a wide variety of sizes, in the planning of astrophotos it is important to know the field of view or angle of view that a specific lens/telescope and camera combination renders. The required angle is solely dependent upon the effective focal length of the employed optics and the sensor size. The formula to calculate the angle of view is:

$$\alpha = 2 \times \arctan\left(\frac{L}{2 \cdot f}\right)$$

Here, α is the desired angle of view, L – the edge length of the imaging sensor in millimeters, and f – the effective focal length of the respective optics in millimeters. If you are using a rectangular exposure format you need to calculate the angle of view in two separate steps, for the short and for the long edge, respectively. With the appropriate software, e.g., Guide (see page 142), you do not need to calculate, but can retrieve the field of view on a sky map based on your own equipment. You can find some specific examples for different field of views in the Appendix.

The Correct Focal Length

Sometimes the question is also vice versa: Which focal length do I need in order to take a format-filling picture of a specific object? For this purpose the formula must be adapted to:

$$f = \frac{L}{2 \cdot \tan\left(\frac{\alpha}{2}\right)}$$

Here, α indicates the extension of the target object, L – the edge length of the imaging sensor in millimetres), and f – the desired effective focal length of the optics in millimeters).

The Ideal Magnification Power

In order to produce high-resolution photos of the Sun, the Moon, and the planets you need to observe the appropriate ratio of focal length, maximum resolving power of the telescope, and pixel size. You have obtained the ideal magnification power when the angle of the maximum resolving power covers at least two pixels, only then will high-resolution be possible. In this case, the following formula applies:

$$N \leq \frac{d_{Pixel}}{0,2805}$$

Here, N – is the denominator of the desired focal ratio, and dPixel – the edge length of a pixel in microns. Let's illustrate this with an example: We are using a Schmidt-Cassegrain telescope with an aperture of 200 mm and a focal length of 2000 mm (focal ratio 1:10). We want to image a planet with a webcam while using the maximum resolving power of the telescope. According to the table (see page 9) this is 0.7".

The pixels of the webcam are square with respective edges of 5.4 μm. Thus, the simple calculation is 5.4 divided by 0.2805, and the rounded-off result is 19.3. In rounding a bit more, we could state that the minimum focal ratio should be 1:20. In practice, this means that a 2× Barlow lens, which increases the focal length to 4000 mm, would solve our problem ideally. However, for time exposures of deep-sky images other rules apply. Here – under normal circumstances – it is not the resolving power of the telescope that determines the useful focal length for a given pixel size, but the prevailing seeing conditions. Note: The term "seeing" refers to the level of air turbulence. If the seeing is poor the stars twinkle heavily, move back and forth in the eyepiece, and appear unfocused or distorted at certain moments. For long exposures with long focal lengths, a night with good seeing (i.e., calm and constant star images) is more suitable. This term should not be confused with transparency (clarity of the atmosphere).

The formula for the ideal focal length for seeing-limited time exposures is:

$$f = \frac{413 \cdot d_{Pixel}}{S}$$

Whereby f – is the desired focal length in millimeters; dPixel – is the edge length of the pixel in microns; and S – is the maximum expected resolution in arcseconds on this particular night, due to atmospheric turbulences (seeing). Let us illustrate this with an example as well. If you are not fortunate enough to observe from an outstanding location, you need to estimate a maximum resolution of four arcseconds for time exposures. If you are using a CCD camera with a pixel edge length of 9 μm under these conditions, then according to the formula the ideal focal length is roughly 930 mm. If you were to use the above-mentioned Schmidt-Cassegrain telescope with an aperture of 200 mm and a focal length of 2000 mm, you would have to decrease the focal length.

You can buy respective focal reducers, which decrease the focal length, for example, by the factor 0.63. In our case, the effective focal length with such an accessory would be 1260 mm, not quite the calculated optimum but a step in the right direction. At the same time the lens speed increases, i.e., the focal ratio improves from 1:10 to 1:6.3, which allows a 0.4 (=0.63^2)-fold shortening of the exposure time.

Megapixel

For digital cameras the number of "megapixels" is often used as a criterion for the price and for a specific model. This number expresses how many million pixels the sensor has. But for astrophotography, not only are the number of megapixels important, but also the dimensions of the sensor and the individual pixels. If a camera has more megapixels than another,

either its sensor is larger while the pixel size remains the same, or its sensor size is the same and it has more and smaller pixels. In the former case, the obtainable field of view is larger, whereas the latter case affords a better resolution if your optics can display the details (see above). In order to benefit from a larger sensor, the optics must be able to expose the larger image format up to the corners, and to provide acceptable image quality even off-center. As experience shows, this becomes more difficult to achieve the closer you get to the 35mm film format (24 × 36 mm).

Chapter 2
The Digital Compact Camera

Application Areas of a Digital Compact Camera

A digital compact camera (also called a point-and-shoot camera) is well suited for a quick, straightforward start into astrophotography. In particular, if you already own such a camera this is a good way to gain your first experience.

Characteristics of a Digital Compact Camera

A digital compact camera is a simple and inexpensive camera for everyday use. Many models are so small that you can always carry them with you and they are hardly noticed. Even many of the newer cell phones have built-in digital cameras. Good quality compact cameras are available for less than $100, whereas the top models may cost a few hundred dollars.

In this book, the term "compact camera" encompasses all digital camera models with a fixed lens. For astrophotography this is a decisive criterion. The issue of the replaceable lens is so significant that even SLRs with a fixed zoom lens will be considered as compact cameras here. Another important characteristic is the type of viewfinder that is used. Most compact camera models have an optical direct vision viewfinder following the principle of the classic rangefinder cameras, where one–unlike SLRs–does

A pleasing scene during twilight is a good subject for a compact camera.

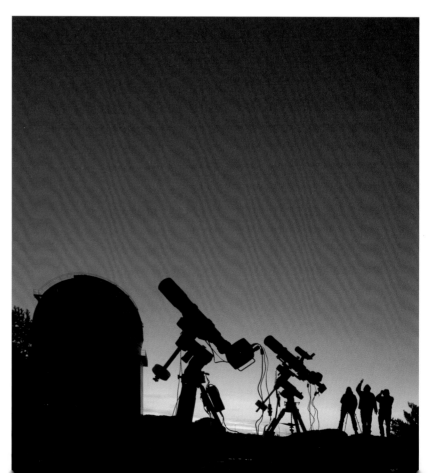

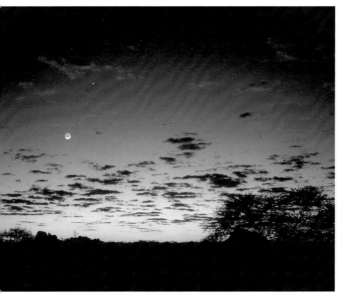

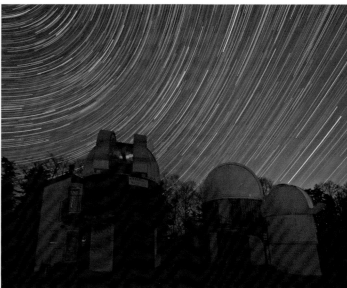

Charming view at dawn in Namibia:
the Moon next to Mercury.

Star trail photo, composition of several single frames.

not look directly through the lens. Often, a small LCD display is available, which shows a live image generated by the sensor, and which can also be used as a viewfinder.

Suitable Photo Motifs for a Digital Compact Camera

Without a Telescope

Digital compact cameras are particularly suitable as a kind of visual notebook, with which you can record interesting settings, weather conditions, and celestial views using short exposure times. These can be photos of a beautiful sunset, the thin crescent Moon with Venus at dawn, a light pillar during moonrise, or a halo effect.

More advanced photographers can also take photos with a more documentary context: In a series of images, you can record the setup and dismantling of your telescope on a scenic mountain top with a photogenic background, or you can shoot a collection of impressive instruments next to their proud owners at a telescope meeting. A compact camera is also useful with regard to documenting a specific configuration of the setup of your telescope. Rather than using a notebook and a pencil, a quick snapshot, with the built-in flash of the compact camera if necessary, is more convenient on a cold, wet, observing night. Still, true astrophotos are feasible with digital compact cameras as well. Depending upon the quality of

the lens, you can take exposures of constellations that are a few seconds long while the compact camera is securely mounted on a tripod. If you do continuous shooting and include the horizon, you can later create a star trail image out of the numerous single frames that shows the movement of the stars relative to objects on the Earth.

With a Telescope

You can piggyback a digital camera on an equatorially mounted and tracked telescope, and can thus use longer exposure times to capture interesting areas of the sky, for example a constellation or the Milky Way. With this technique you can also later combine several frames into a single image, revealing much more detail than can be captured in a single frame or seen with the naked eye.

If you would like to take pictures through your telescope, you will face a few limitations. Because you cannot remove the lens of the camera, you can only use afocal photography, i.e., you place the camera with the lens directly behind the telescope eyepiece. Thus, you can attain impressive images of the Sun and the Moon, as well as eclipses. Other brighter objects such as planets are still within reach of the afocal photography method for compact cameras, but you can achieve better results here with inexpensive webcams. Long exposures of faint deep-sky objects are not recommended as motifs for compact cameras.

The eclipsed Moon is a suitable object for a digital camera through the telescope.

Contrails of a plane in front of the thin waxing Moon.

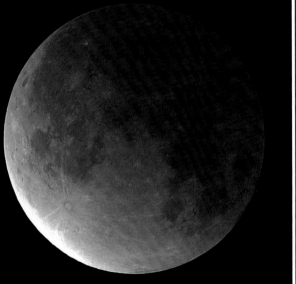

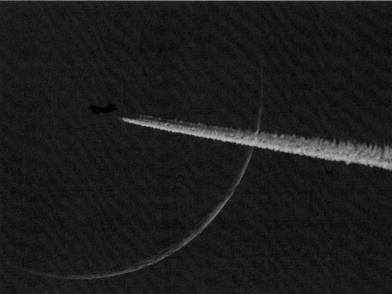

Advantages and Disadvantages of a Digital Compact Camera

Advantages

A compact camera is an inexpensive and easy to use camera that you can take with you practically anywhere due to its small size and typically low weight. The camera is ready for use quickly and it is great for taking snapshots. When photographing, all technical tasks are handled automatically. This can be an advantage in hectic situations. For its operation no computer is necessary.

Disadvantages

A disadvantage of some compact cameras is that they have automatic modes that cannot be switched to manual. Sometimes they lack features that are necessary for sophisticated astrophotos, such as a connector socket for a remote control release, or a filter thread on the lens front for simple mounting to a telescope.

You can find a direct comparison of the application areas of the different camera types in the Appendix.

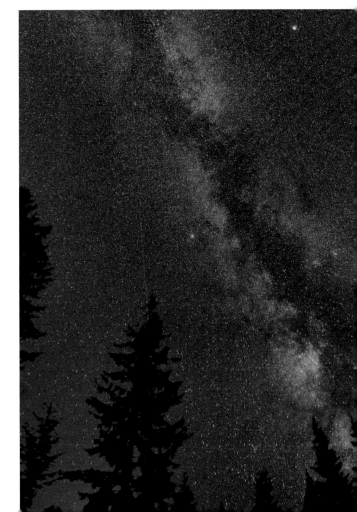

The Milky Way above the tree tops of the Black Forest, photo with tripod.

The Digital Compact Camera

Advantages	Disadvantages
Inexpensive	Lens is not replaceable
Easy to use	Often, automatic modes cannot be switched off
Small size, low weight	Mounting to the telescope may not always be easy
Suitable for snapshots	Not every compact camera has the features that are useful for astrophotography
Fast, automatic operation	
No computer or external power supply necessary for exposures	

Buying Tips for Digital Compact Cameras and Accessories

If you are planning to purchase a compact camera to take astrophotos, you should consider a few things before the actual purchase. A wide variety of designs are available, and not all cameras are equally suited to this purpose.

Tips for the Purchase of the Camera

With compact cameras, in particular, you find a vast range of offerings. The main advertising argument is usually the number of pixels of the camera sensor (see pages 11-12). If you are using good optics respectively, more pixels means that you can get larger prints from your images without individual pixels becoming visible (i.e., noise). However, compared to digital single lens reflex (DSLR) cameras, compact cameras have very small sensors with very small pixels, and thus display more noise. Therefore, photos taken with a compact camera are never as good as photos taken with a DSLR. For astrophotography though, it is an advantage if your compact camera includes the following features:

Ability to Switch Off Autofocus

When you try to take pictures with your compact camera through a telescope, you will notice that autofocus systems generally fail when it comes to astronomical motifs.

LCD/TFT Displays

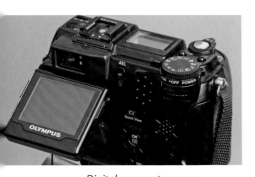

Digital compact camera with pivoting display.

Taking pictures through the telescope disables the optical viewfinder of the compact camera if it is not an SLR camera. The only way to check your image in this case is the liquid crystal display (LCD) or thin film transistor (TFT) display on the camera back, with which you can judge the field of view and the focus. A rotating and pivoting display that allows a comfortable viewing position even if the camera is oriented vertically upwards is very useful. The display is also important in order to check the exposure and the exact focus after you have taken the image. A zoom function with which you can enlarge parts of the image is also convenient.

Connector Socket for a Remote Control Release

When mounting the compact camera to a telescope it is not advisable to release the shutter by pressing the shutter release button on the camera body as camera shake would be an almost inevitable consequence. A

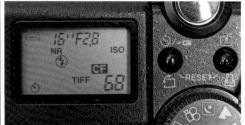

Connector sockets for remote control releases of different compact cameras.

Camera display showing manual settings.

remote control release is a more elegant and almost contact-free solution. Not all camera models have an available remote control release, and not all cameras have a connector socket. A possible solution would be the self-timer, however in the long run, working with this is rather cumbersome.

Ability to Switch Off the Flash

Nearly every digital compact camera comes equipped with a built-in flash. For astrophotos, it is crucial that you have the option to switch off the flash.

Manual Exposure Setting

Not only the autofocus, but also the automatic exposure is usually pushed to its limits when shooting astronomical scenes. Ideally, you can manually set the exposure time, as well as the aperture. The maximum exposure time should be as long as possible (minimum 16 sec). Still, with many camera models you will only be able to perform manual exposure compensation. This allows you to correct the value calculated by the automatic mode by either overexposing or underexposing. Adjustment steps of plus/minus two should be the minimum.

Filter Thread

A filter thread on the lens front of a compact camera makes for simple mounting to a telescope. If you intend to do this, you should pay attention to the inclusion of a filter thread.

Fixed Lens

When operating the camera on the telescope with the afocal method, it is convenient if the lens does not change its length, neither when zooming nor when focusing. In both instances, this means that the effect is achieved by adjusting lenses in the interior of the objective. If this is not the case,

you need to take care that the protruding camera lens does not hit the lens of the telescope's eyepiece.

Reliable Power Supply

Astrophotography, with its long exposure times, can quickly drain a camera's batteries. Take note of how long a camera model works with its in-camera battery, and whether it can be connected to an external power supply.

Built-In Noise Reduction

A camera with built-in noise reduction for time exposures can be helpful, especially for beginners.

Although you can achieve the same result later during image processing with the generation of "dark frames" (see page 118), it is more comfortable to work with the existing camera feature if it is available.

Storage of Exposure Data

It is useful, though not mandatory, that the camera store exposure date and time, as well as technical data, such as shutter speed, aperture, and ISO speed as part of the image file. Given the option, you should choose a camera with the ability to save images as RAW or TIF files as opposed to the JPG format.

Small Front Lens

With a small front lens you decrease the risk that pictures taken through a telescope suffer from vignetting, i.e., they have dark, shaded corners.

Useful Accessories for Your Compact Camera

For astrophotography some accessories are useful that are not usually supplied with the camera.

Remote Controller

A remote controller is desirable for vibration-free shutter release of the camera. A cable release acquired from the camera's manufacturer would be ideal. A wireless remote control, which works with infrared or radio signals, can also be used for astrophotography, but could cause problems in practice depending on low temperatures and the orientation of the camera.

Photo Tripod

For pictures of constellations or dawn scenes, a tripod is an essential piece of equipment to avoid blurry images due to camera shake. If you do not want to burden yourself with a bulky tripod, in most cases, a table top tripod or small clamp will be sufficient (see figure below and page 75 bottom-right). However, this restricts the selection of your photo location because you always need free space or an object on which the clamp is attached.

Ball Head/Clamp for Mounting on the Telescope

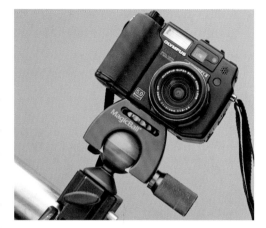

For photos in which the camera needs to be mounted piggy-back on the telescope, a fixture is required (see page 75). Some telescopes include a screw with a photo thread on top of the tube clamp specifically for this purpose. However, you should not attach your camera directly onto this screw, because then you have no adjustability and are very restricted in regard to your angle of view. Instead, get a ball head mount that can be attached to the screw and onto which you mount your camera.

Thus, you can turn the camera independently from the telescope to ensure that the telescope tube is not showing in the picture. Alternatively, you can screw a clamp onto the counterweight bar of the telescope mount, but during longer exposures this only works if the bar does not turn while the telescope is moved on the declination axis.

Camera with clamp and ball head on the counterweight bar of a telescope.

Connection Adapter for the Telescope

For photography through the telescope, astronomy shops offer special accessories. If your camera has a filter thread, you only need to find the corresponding adapter to fit your filter thread (see figure, page 22, center and right). Without a filter thread, the best solution would be to inquire in photo shops if a filter attachment adapter is available for your camera model. With an adapter you can retrofit your camera with a filter thread. If this is not feasible, you need to employ a cumbersome and not very stable bracket, which uses the tripod thread and adjustability in all directions to lock the camera into position (see figure, page 22).

UV/IR Blocking Filter

The lens of a compact camera is usually only corrected for the visible light. This means that ultraviolet (UV) and infrared (IR) light, with respectively shorter and longer wavelengths than visible light, reaches the camera sensor as well, and thus creates blurred, superimposed ghost images. You can

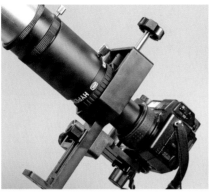

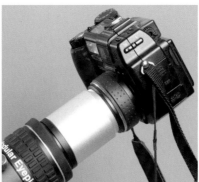

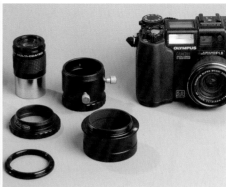

Mounting of a camera without filter thread. *Telescope mounting of a camera with filter thread. Accessories at right.* *Clockwise from bottom left: adapter ring, adapter, eyepiece, eyepiece holder, casing (bottom right).*

counteract this by integrating a UV/IR blocking filter into the optical path. You can, for example, attach such a filter to the filter thread of the eyepiece.

Taking Astrophotos with a Digital Compact Camera

Now, you can get your digital compact camera ready and aim it at the sky: on a tripod, mounted on a tracked telescope, or through the eyepiece of a telescope.

Photos With a Tripod or Piggyback

The compact camera mounted on a tripod and outfitted with a remote controller is the equipment for images of pretty dawn scenes and constellations. In the box on the right you will find suggestions for taking your first exposures using a tripod.

If you mount your camera piggyback on a telescope that is tracking the rotation of the sky, you can take longer exposures of celestial areas. Make sure that you have a stable mounting allowing you to expose for a few minutes.

Freehand Snapshot Through the Telescope

For the occasional snapshot of the Sun or the Moon, it is sufficient to hand-hold the camera behind the telescope's eyepiece, using the camera's display as a viewfinder. But be careful: Never take pictures of the Sun without

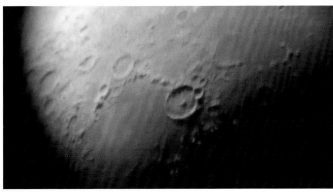

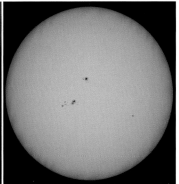

Freehand photo of the Moon with dark corners, shot through the telescope.

The Sun is a nice subject for a snapshot.

an appropriate filter in front of the telescope lens! If your camera has a switch-off autofocus mode, then focus on a distant object, and then switch off the autofocus in this position (position "infinity"). Now focus using the focus knob of the telescope. Try to obtain a fast shutter speed, if necessary by increasing the ISO speed of the camera, and release the shutter as soon as you are pleased with the image on the camera's LCD display. Afterwards, you should display and enlarge the image on the control display, to check if you have hit the correct focus point. If the automatic exposure mode fails, switch to manual exposure or–if available on your camera–use the manual exposure compensation (override). If the image has a color cast, you do not need to delete it right away.

Tips for the First Photo with a Tripod

A nice motif is a pretty configuration on the western evening sky such as the Moon next to Venus. By including the silhouette of a building, a person or a telescope, you can produce striking images.

During dusk your camera's automatic mode for exposure and focus should still work. When it gets darker, you should set the exposure manually.

You can still remedy this later during image processing. Just delete out of focus and blurred images, and try again. If you detect dark image corners, you either need to move the camera closer to the eyepiece or you need to zoom the camera to a longer focal length. With this simple technique you can already succeed in taking amazing images of the Sun and the Moon!

A cell phone with a lens or compact camera in freehand operation.

Longer Exposures Through the Telescope

If you are more ambitious, you need to mount the camera with its lens behind the eyepiece of the telescope. For these long exposures you will certainly not work freehand anymore, but will use a connection adapter in the same line that was introduced on page 22. This will provide a secure and stable connection between the focuser and the camera.

	Taking Pictures Through the Telescope With a Compact Camera
1.	Apply a UV/IR filter to an eyepiece with a long focal length
2.	Place the eyepiece in the focuser of the telescope
3.	Focus the camera on a distant object
4.	Switch off the autofocus
5.	Deactivate the camera's flash
6.	Select the file format with the least compression and the maximum file size, preferably RAW, TIF, BMP, or if these are not available, JPG with the highest image quality
7.	Switch off automatic exposure
8.	Set white balance to daylight
9.	Mount the camera behind the telescope
10.	Attach the remote controller to the camera
11.	Focus the image on the camera LCD display with the focus knob of the telescope
12.	Take first test exposures with a large aperture and a manually set exposure time
13.	If necessary, correct your image illumination by adjusting the camera's focal length (Attention: In the process, the camera lens may extend to the front and hit the eyepiece)
14.	Focus again using only the focus knob of the telescope
15.	Shoot test exposures to find the best exposure time and check the images for overexposures (see page 26)
16.	Take 10 or 20 pictures with the best settings from which you can later select the best photo

Preparation of Camera and Telescope

At first, use an eyepiece with a long focal length for your telescope (i.e., low magnification) and screw a UV/IR blocking filter into it. If your camera has a switch-off autofocus mode, then focus (just as with the snapshot

described on pages 22-23) on a distant object and switch off the autofocus in this position (position "infinity").

Now, deactivate the built-in flash. As a file format, utilize the one with the least compression and the maximum file size. If the camera offers the RAW file format, this is the optimum choice for astrophotos. RAW here refers to the uncompressed, unprocessed raw image format. If RAW is not offered, opt for the TIF or BMP format, where no file compression involving data loss is performed either. Less suitable is the JPG format, because it involves exactly such a lossy compression. If you have no choice other than JPG, select the highest image quality setting available, as this implies the least compression. Keep in mind that you can always reduce or compress the image later on the computer; however, under no circumstances will you be able to restore information that was initially lost through compression.

Connection to the Telescope

Here, the lens of the camera must be placed within the extension of the optical axis of the telescope's eyepiece. The front of the camera's lens should be placed as close as possible to the back lens of the eyepiece without touching it, and thus risking possible damage. Take into consideration that the camera lens could extend to the front due to zoom or autofocus. A truly secure and rigid connection between the focuser and the camera can only be achieved with a specific adapter for the filter thread of your camera.

Focus and Exposure

To avoid vibrations of the camera use your remote controller (or at least the self-timer) for all exposures. Focus your image on the camera display with the focus knob of the telescope. If possible, use entirely manual

Mounting a digital compact camera to the telescope.
__1.__ Adapter, camera lens with filter thread. *__2.__ Camera with adapter. __3.__ Camera mounted to the telescope.*

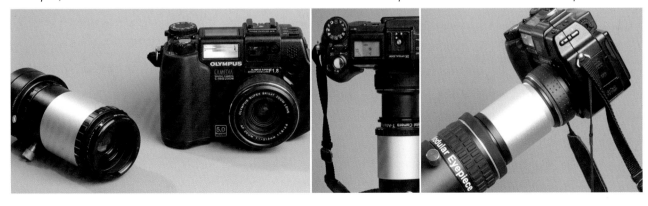

exposure settings, and select a large aperture (small f-stop number) and a corresponding exposure time for a series of test exposures.

Manually set the white balance (adjustment to the light conditions) to Daylight. If your image is bright only in the center and loses brightness towards the periphery, especially at the corners, then it is suffering from vignetting. Position the camera closer to the eyepiece or zoom in to solve this problem.

With each modification of the focal length you should recheck the focus and correct it if necessary. Do take your time with focusing, because the most common reason for unsuccessful astrophotos is inaccurate focusing. Owing to the small camera display, however, it can be difficult to hit the focus at first go. At any rate, several test exposures per image setting are useful, because some pictures may be out of focus despite the best focus having been found, due to atmospheric turbulence at the moment of exposure.

Set Exposure Time

Experiment with various exposure settings to find the best combination. Avoid overexposures because this totally saturates some pixels, which then appear bright white. These overexposed areas are neither attractive nor do they contain any image information that can be made visible through subsequent image processing.

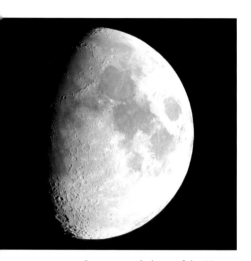

Overexposed photo of the Moon: The bright areas are washed out and without structure.

The histogram for the picture of the Moon above: The values are "stacked to the right."

The Histogram

The histogram (figure left) is a part of every image processing software and even appears on the small display of some compact cameras during image review. The horizontal axis displays the brightness values from pure black (leftmost) to pure white (rightmost). The height of the curve shows how many pixels have a particular brightness. For everyday photos, the curve should not reach the far right or far left end, i.e., it should not contain pure white or pure black pixels. Yet astrophotos are different: Usually you find high values on the left end (many pixels are pure black due to the large areas of dark sky) and some values may be completely saturated (e.g., bright stars in the image).

It is often difficult to evaluate the accuracy of the exposure on the small camera display. If your camera can show the histogram, you can use it to check if any (and how many) pixels are completely saturated, which might indicate an overexposure (see also box above). If your camera does not allow the complete manual setting of the exposure, you may be able to use the camera's exposure compensation. For example, if the automatic mode

produces overexposures you can try a manual correction selecting shorter exposures.

The First Motif

A suitable object to start with is the waxing crescent Moon. It is conveniently located in the evening sky and along its light/dark border it offers a rich variety of craters, mountain ranges, and other formations that appear 3-dimensional in the oblique rays of the Sun. These Moon pictures are not only easy to take, but provide quick success and a first sense of achievement.

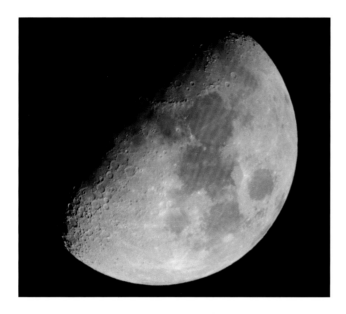

A correctly exposed picture of the Moon through a spotting scope (telescope used for the observation of terrestrial objects).

Tips and Tricks

Sun Warning: Never aim your digital compact camera toward the Sun without a proper protection filter in front of the lens. If you are using it with a telescope, make sure that the telescope lens is protected with a proper solar filter (see page 6). Put on the lens cap during exposure breaks.

Monochrome Images: If your camera offers a black & white mode, you can try to employ it with largely monochrome subjects, such as the Sun and the Moon. If you feel inclined, you can add color to the images again later during image processing.

Image Processing

Here, you can learn how to greatly improve a scenic landscape shot with clouds and stars, and how to create your first digital star trails.

Scenic Shots of the Night Sky

Due to the limited possibilities in regard to the setting of exposure time and aperture, the images taken with a digital compact camera, for the most part, will require some subsequent processing.

Let us take an example image with Sirius (at the center) and the constellation Orion, which you can download for practicing from http://www. astromeeting.de/astrophotography_digital.htm (Image **1**).

Brightness and Color

Open the file with Adobe Photoshop image processing software (see page 141). For an easy start, let the software decide the automatic settings for brightness and color. For this you select the menu items

1 Original image.　　　　　　　　　　　　　　*2* Result with automatic processing.

Image>Adjustments>Auto Color and Image>Adjustments>Auto Contrast. The result is shown in Image **2**.

Photoshop tried to convert your nighttime shot into a daylight shot. Although the color balance was clearly improved, this is not what you want. In order to create an impressive nighttime image, the following menu item is more helpful: Image>Adjustments>Curves …

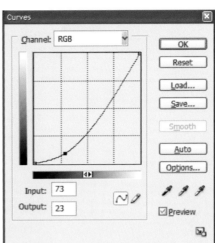

As shown in the curves dialog box, you can click and drag on the straight line with the mouse to change the shape of the curve. The result (Image **3**) more closely resembles a nighttime shot.

Image Rotation

However, you are not done yet! You still have to fix the slanted horizon line, which is the result of the camera not having been mounted squarely on the tripod. No big problem though, because Photoshop allows the free rotation of the image. For this purpose choose Select>All from your drop-down menu, and then use the *Move Tool.*

3 *Image after manual adjustments.*

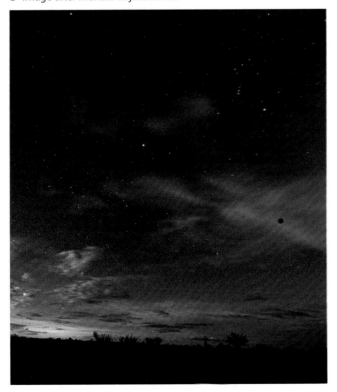

Next, enlarge the file window until it is larger than the displayed image (if necessary, reduce the display size of the image) and a gray area surrounding the image becomes visible. If you now place your cursor outside the image corners, the cursor becomes a curved, two-sided arrow. While clicking and dragging the cursor you can now rotate the image freely. Using the horizon as orientation, rotate the image until the horizon and the lower edge of the image are parallel.

In order to check the horizontal alignment, you can drag the image downwards by clicking until the line of the horizon and the edge of the image overlap. If the rotation angle is correct you can move the image back up again.

Dust and Pixel Defects

The circular black spot that is visible on the cloud in the original image (Image **1**) could be a dust particle on the sensor.

You can learn how to remove dust and defective pixels on the internet at http://www.astromeeting.de/astrophotography_digital.htm.

4 *Rotated image before cutting the edges.*

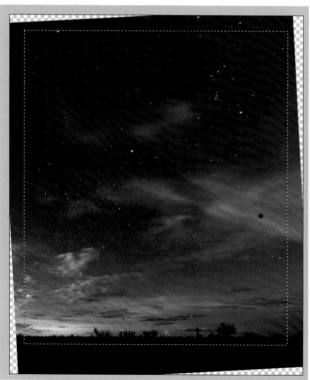

5 *Finished image!*

When you are satisfied with your change, click on the rectangular Marquee Tool ⬚. A dialog box will appear asking if you want to apply your change, which you confirm by clicking on *Apply*. Your image is rotated now and with Ctrl+D you can deselect your selection. Now use the mouse cursor to open a box in the image in order to crop the "slanted" edges (Image **4**). By selecting Image>Crop you can crop all image areas outside of your selected box.

Reduction of Image Noise

Through the image processing, the image noise has slightly increased. You can reduce this noise by using the Filter>Blur> SmartBlur option. Just select the settings as shown in the dialog box at right.

You have now accomplished the final result (Image **5**, page 30)!

Create Star Trail Images

As opposed to traditional film photography, exposure times longer than a few minutes are neither recommended nor are

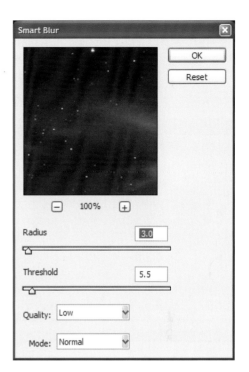

1 A single image (cutout).

they always possible with digital cameras due to the dramatic increase of image noise. If you would like to take images in which the stars are trailing due to the Earth's rotation, you need to take many single frames, then stack these in Photoshop. For such a continuous shooting you need to mount your camera on a solid tripod.

Eight images (DigiCam1.jpg up to DigiCam8.jpg), which you can also download from http://www.astromeeting.de/astrophotography_digital.htm, will exemplify this stacking method. The images were taken consecutively in the numbered sequence.

Create an Image with Different Layers

As an exercise, open all eight images in Photoshop. Image **1** on page 31 displays a cutout from the first exposure. Next, open the second file DigiCam2.jpg and use the drop-down menu Window>Layers to display the *Layers* palette. This single image consists of only one layer as shown at left.

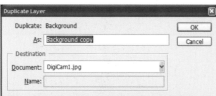

Now click on the layer *Background* with the secondary mouse button, then select from the drop-down menu Layer>Duplicate Layer.... The following dialog box appears (see center-left). Here, it is important that you select the file "DigiCam1.jpg" from the *Destination* drop-down menu.

Confirm your selection by clicking *OK*. Photoshop will now copy the file DigiCam2.jpg as a second layer to the file DigiCam1.jpg. Next, select file DigiCam3.jpg and copy this file, as well as the new layer to DigiCam1.jpg. Repeat this for all images up to DigiCam8.jpg.

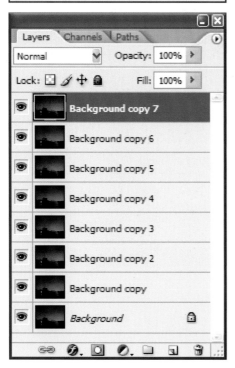

If you now take a look at the file DigiCam1.jpg you will notice that it consists of eight layers (see bottom-left).

Stack Layers

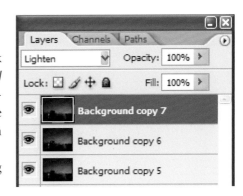

Excluding the layer named *Background* (bottom layer), click on all layers consecutively and select *Lighten* instead of *Normal* from the blending mode drop-down menu in the upper left-hand corner. Now you only need to merge the layers with the menu item Layers>Flatten Image and you have succeeded with your first digital star trail image (Image **2**)!

The screenshot at right shows *Layers* with the blending mode set to *Lighten*.

2 *Finished star trail image.*

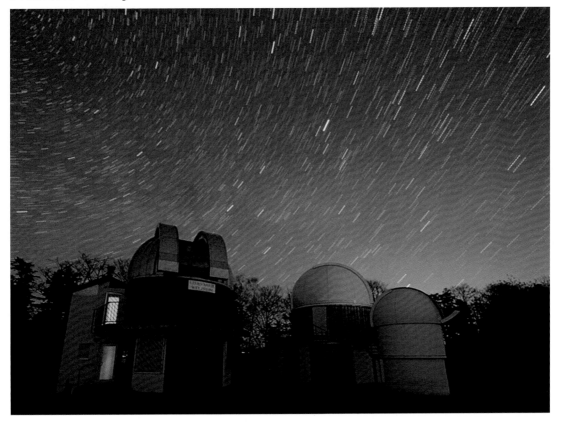

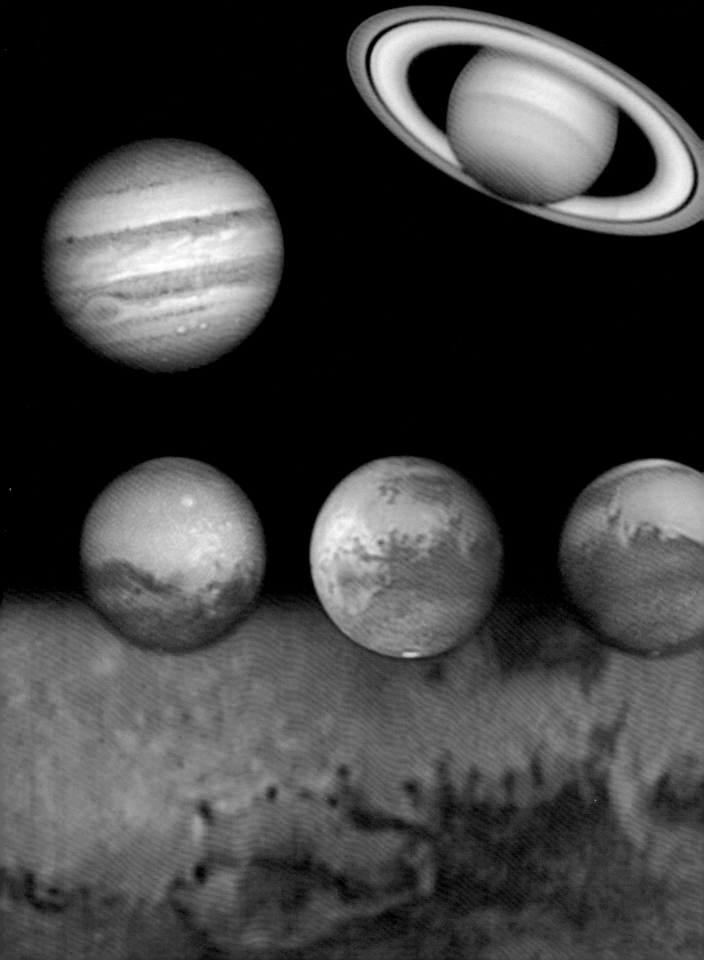

Chapter 3
The Webcam

Applications of a Webcam

A webcam is commonly used for real-time transmission of live images on the Internet; for video conferences or video phone calls; as a visual component for online chats; as well as for video surveillance and security purposes. It can only be used in conjunction with a PC or laptop.

Characteristics of a Webcam

"Webcam" is the abbreviation for web camera. It focuses on moving images and lacks the high quality and high resolution for single frame images. However, when used in combination with a telescope, a webcam is the ideal camera for lunar and planetary astrophotography.

In addition to the actual camera, the standard equipment of a webcam includes a lens, a PC or laptop computer, and the required operating software. And of course, a webcam cannot be used for astrophotography without a telescope. Unlike other cameras, it does not provide the capability for longer exposures. Webcams are rather inexpensive; even when including the accessories, you should be able to purchase one for less than $150. Of course, this does not include the telescope or the computer that are necessary for the operation of the webcam. However, the software for the analysis of the recorded image series is available free of charge on the Internet as so-called "freeware" (see page 54).

Suitable Photo Motifs for a Webcam

Due to the small imaging sensor of a webcam the primary motifs for this camera type are objects of our solar system (see below). Ideal objects are Venus with its phases; Jupiter with its colorful, richly textured cloud formations; Saturn with its magnificent rings; and Mars with surface details

Bright Venus crescent, Mars with white polar ice cap and distinctly visible surface details, Jupiter with its differently colored cloud bands, and the ringed planet Saturn.

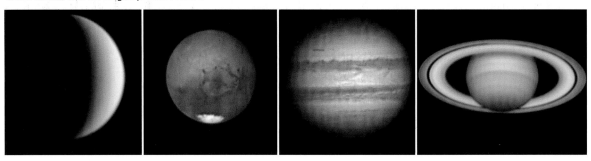

when it is at (or close to) perigee. With a webcam you can quickly and easily capture closeups of intriguing details on the Sun or Moon, e.g., sunspots, prominences, and craters.

A marginal area of astrophotography that is frequently disregarded is the photography of double stars. A webcam can also be used for this, if the elements of the double star exhibit a minimum degree of brightness.

It is possible to display the difference in brightness of the individual stars, as well as their color.

With this list of motifs, however, the application potential of a webcam for astrophotography is nearly exhausted, because its maximum exposure time is 1/25 seconds. This exposure time is not long enough, for example, for imaging deep-sky objects—unless you remodel your webcam slightly. You can find instructions for the remodelling in many places on the Internet; in this book the webcam will be presented in its unmodified form, because the remodelling requires a change to the electronics, which would void the product warranty of the manufacturer.

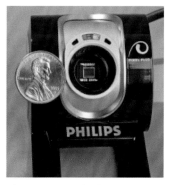

The comparison with a US penny shows how small the sensor of a webcam is.

Advantages and Disadvantages of a Webcam

+ Inexpensive

Webcams are among the least expensive imaging devices for astrophotographers and the accessories are affordable as well.

+ The Ideal Planetary Camera

The achievable image quality of planetary images is—despite the low price—superior to that of a digital SLR, and even to that of an astronomical CCD camera! How is that possible? Firstly, the small imaging sensor of the webcam is not a disadvantage for planetary imaging, because the image of the planet easily fits on the sensor area. Secondly, planetary imaging requires taking as many single frames as possible within the shortest amount of

Sunspots, the end of a Saturn occultation by the Moon, the colored double star Albireo, and the lunar craters Copernicus (top) and Eratosthenes (left).

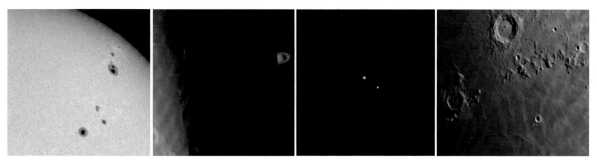

time. You need these numerous images to cheat on the seeing, i.e., the atmospheric turbulences and the resulting image deterioration.

If you have dozens, hundreds, or even thousands of images of a single planet, specialized software can identify the best and sharpest images, stack them, and "add" them, resulting in a sharp, detailed, and low-noise image of the respective planet.

In particular, when photographing Jupiter and Mars the exposure time is limited to a few minutes; otherwise, the single frames cannot be stacked and added precisely without causing blurs due to the planet's rotation. Thus, many single frames must be shot in a short period of time. And, it is here where the webcam shows its strength; it can capture 10, 15, or even 20 images per second and save them as a video file.

+ High Sensitivity

A webcam offers a higher sensitivity than conventional film–in particular, the models recommended for astrophotography. Hence, it allows shorter exposure times, which in turn helps to "freeze" the image movements caused by seeing.

+ High Resolution/Color Images

The most frequently used models have tiny pixels with an edge length of 5.4 microns (a micron = 1/1000 mm). Therefore, you can realize sharp details while utilizing the maximum resolving power of your telescope, without increasing the focal length to extreme values. In most cases, the use of a 2x or 3x Barlow lens is perfectly sufficient.

+ Good Focus Control

For successful photos of the planets, the Sun, and the Moon, precise focusing is essential, and here the webcam convinces as well. It provides a live image on your PC or laptop monitor, which conveys a direct view of the focus quality. The system-related problems, such as focusing with long focal lengths and turbulent air are not solved with the webcam, but the focus control with a live image on the monitor beats any viewfinder system.

+ No Tangled Cables

It is also an advantage that the power supply, as well as the data transfer, is carried out with just one Universal Serial Bus (USB) cable, which minimizes the risk of tangled cables.

The Webcam

+ **Advantages**	– **Disadvantages**
Inexpensive	Tiny sensor, small field of view
High sensitivity, short exposure times	No bulb exposures possible
High resolution, sharp details	No cooling to reduce the noise
Provides color images	Huge amounts of data
Good focus control	Losses through data compression
No cable tangle	Operation impossible without a computer
Unbeatable for planetary imaging	Operation without a telescope not reasonable

A webcam in operation. A single USB cable provides the data transfer as well as the power supply for the camera. The laptop is used for the focus control.

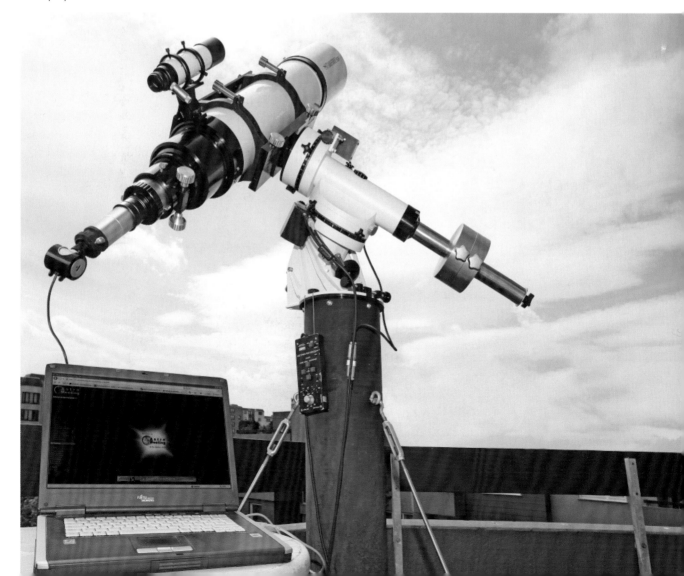

Disadvantages

The disadvantages of a webcam are its tiny sensor, the missing capability for bulb exposures, and the lack of sensor cooling to reduce image noise, all of which limits its use to certain application areas. However, since it is primarily used as a planetary camera, these deficits are negligible. The most significant limiting factor, though, is the deterioration of the single frames through data compression. This data reduction is necessary to transfer the amount of image information via the USB port to the computer. An increase in the number of images taken per second results in a loss of quality due to data compression.

You can find a direct comparison of the application areas of the different camera types on the table in the Appendix.

Buying Tips for Webcams and Accessories

Webcams are inexpensive, and the variety of available types is by far not as large as with compact cameras. However, a webcam by itself is not sufficient, you still need additional accessories.

Tips for Purchasing a Webcam

Webcams with a CCD (charge-coupled device) sensor are better suited for astrophotography than those with a CMOS (complimentary metal-oxide semi-conductor) sensor. Webcams with CCD sensors are available from Philips, Celestron, and Meade.

Webcams and more, from left to right: Philips ToUCam 740k, Philips ToUCam Pro II PCVC 840k, Celestron NexImage, Meade Deep Sky Imager, Meade Lunar Planetary Imager.

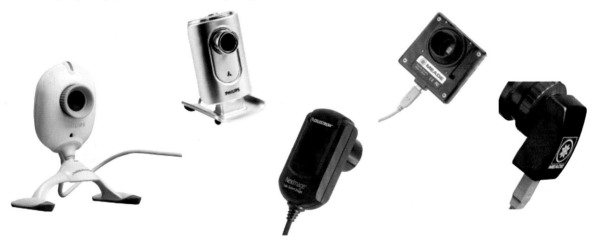

Philips' latest model with a CCD sensor is the SPC900NC; its predecessor, which is still available to some extent, is the ToUCam Pro II PCVC 840k. All descriptions in this chapter regarding exposure and image processing refer to these products. If you are using a webcam from a different manufacturer with other control software, the operation methods may significantly differ from the descriptions in this book. Yet, if that is the case, still read the respective sections carefully in order to learn what is important. Then, you just need to find the appropriate settings in your own webcam's software.

Celestron offers a camera called NexImage, which technically corresponds to a Philips webcam, but is enhanced through specific software for astronomical purposes. If you are using a Celestron NexImage camera you can precisely follow all the steps outlined below. In certain countries (and this includes the USA), some of the Philips webcam models are not offered (owing to Philips' product policy) or are difficult to obtain. In this case, the Celestron NexImage camera provides an adequate alternative. The NexImage webcam is delivered ready for connection; a separate telescope adapter is not required.

Under the names of "Lunar Planetary Imager" and "Deep Sky Imager", Meade Instruments Corporation also offers devices that are similar to webcams with regard to technology and sensor size. You can even realize longer exposure times with the "Deep Sky Imager". Yet, their control software varies substantially from the descriptions in this book. The instructions for exposure and image processing cannot be reproduced with these cameras.

Instead of a webcam, some photographers use digital video cameras for taking images of the planets, the Sun, and the Moon. The quality of each individual frame is much higher here, since no data compression is performed (or only a minor one). The prices, however, are much higher than those of webcams. A few examples of these video cameras are the models from The Imaging Source that are offered with a Firewire port, and the Lumenera models offered by Framos Electronics with a USB 2.0 port.

Useful Accessories for Your Webcam

The purchase of a webcam includes a lens, as well as the respective operating software for the camera. The lens is not usable for astronomical purposes, and can simply be unscrewed and removed.

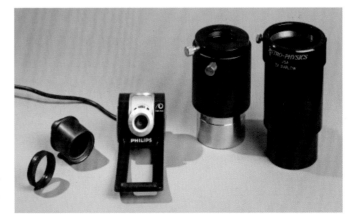

Webcam and accessories (from left to right): UV/IR blocking filter, telescope adapter, extension tube, 2x Barlow lens.

Telescope Adapter

Instead of the lens, you need an adapter for attaching it to a telescope, which must be purchased separately (see figure, page 41). With just this, you will already be well equipped for images of the Sun and the Moon– apart from respective solar filters (see page 6).

Barlow Lens and Extension Tube

In order to produce large enough images of planets, the primary focal length of most telescopes is not sufficient. Therefore, you need an additional Barlow lens that increases the focal length by a factor of two to five. Although the lens predetermines the magnification factor, it can be varied to a certain extent by using extension tubes between the Barlow lens and the webcam.

Adapter for Eyepiece Projection

As an alternative to increasing the focal length with a Barlow lens, you can also opt for the eyepiece projection method. For this method you need an adapter that screws into the eyepiece on the front end, and permits the attachment of the camera on the back end. The adapter for eyepiece projection is less expensive than a good Barlow lens; however, the Barlow lens produces superior imaging results than the projection with a regular eyepiece.

UV/IR Blocking Filter

In particular, when using a refractor it is helpful to block the ultraviolet and infrared light, since most refractors do not focus these wavelengths at the focal point of visible light. The webcam, however, records these wavelengths, which can lead to a loss in sharpness. UV/IR blocking filters especially made for these purposes are readily available. You can purchase a 1.25" size, and then simply screw it into the filter thread of the webcam adapter.

Analysis Software

You can download the software for the analysis of the planetary videos free of charge from the Internet address http://www.astronomie.be/registax/. (See more on this topic on page 54.)

Taking Astrophotos with a Webcam

When using a webcam for astrophotos, the camera either replaces the telescope eyepiece (prime focus photography; if necessary, increase the focal length with a Barlow lens), or you may use an eyepiece projection for which the webcam body is attached behind the eyepiece.

Before the First Exposure

Prior to initial use of your webcam, you should perform the following preparations and trials at home, during daylight hours. Thus, you can solve potential issues unhurriedly.

Start Up the Webcam

Prior to the first exposure of night sky objects, the camera software must be installed on your computer, and the camera must be started. After having installed all drivers, you can try to record a first test video with the supplied software. Just use the regular lens of the webcam for this test and experiment with different settings for the exposure control. Find out how to deactivate the automatic exposure setting in the software. Only then can you manually set the controls for single frames, frame rate per second, image brightness, color saturation and color balance, gamma value, and image gain. After some trial and error, you will notice that (depending on the object) you will find a better setting manually than with the automatic exposure of the software.

Setting of the gamma value in the supplied software. *Remember to switch off the sound!*

For use as a planetary camera it is very important that you switch off the sound for the exposure, because the webcam contains a microphone. Sound requires transmission capacity at the expense of attainable image quality. Therefore, locate the setting in the software where you can set the default to mute the sound.

Prepare the Computer

Now you can start a test exposure, irrespective of the subject. Save your data and image stream as a video file with the ending AVI (Audio Video Interleaved). Do not select a duration setting for your video that is longer than 2-3 minutes, and monitor how large the video file is after just a brief recording time. Pay attention during the exposure and the later during playback to see if all images were actually saved.

With a moving object, missing images are noticeable by the fact that the movie "jumps" to the next frame. The reason for these lapses can be that your computer cannot keep up with the data stream: not enough memory or a slow hard disk can be the cause of this. You can try to improve the performance with little effort by deactivating the installed software for virus scanners and firewalls for the duration of the exposures. If you do not have a connection to the Internet during the exposure anyway, you can do this safely: But remember to reactivate the software afterwards! It may also be helpful to close unused software applications, to uninstall an application, and/or to defragment the hard disk in order to reduce unnecessary and superfluous data.

Modern operating systems also offer the capability to create profiles. Thus, you could create a special profile that activates only those hardware and software components that are absolutely necessary and deactivates all others. This can help you to gain performance resources on your computer. If all of these suggestions are to no avail you should try lowering the frame rate, for example from 20 to 10 images per second.

Video files become quite large after just a few minutes.

Save Disk Space During Planetary Imaging

You can also try the following option to save disk space and to increase the performance during the saving of the data: Some webcams offer the possibility to limit the imaging area to the central part of the image sensor, and to thus capture fewer pixels per single frame. For imaging planets, the central part is sufficient in most cases, and the dark and bland surroundings can be omitted.

For this reason, you should shoot several test videos using different resolution levels in order to compare them afterwards. The maximum physical resolution of many webcams is 640 x 480 pixels.

Important note: Depending on the driver version, the setting 320 x 240 pixels in the recording software does not necessarily match with the desired option where only the central part of the sensor is used, but instead it combines four pixels respectively into one pixel. This corresponds to a so-called "2 x 2 binning", where the image indeed consists of fewer pixels, but the effective resolution is reduced. You can recognize this on the exposure of your test videos because the recorded field of view is not reduced when compared to an image in full resolution. Thus, you are imaging the same angle of view, but in a reduced resolution.

For our purposes, a setting of 352 x 288 is preferable. Here, the sensor indeed uses its full resolution, while ignoring the border areas. You can recognize the reduced field of view in the test video (see page 46).

Connecting the Webcam to the Telescope

The next step during your "dry run" is to connect the camera to your telescope. As mentioned above, there are two options for this: Either to work in prime focus with a Barlow lens or to use an eyepiece projection. In both cases, you need to remove the supplied lens of the webcam and replace it with the webcam adapter. In order to remove the lens, you first need to pry the silver-colored lens tube out of the camera body with a sharp knife. For

Mounting of a webcam to a telescope
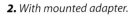
1. *With blocking filter and adapter.* **2.** *With mounted adapter.* **3.** *With adapter in the focuser.*

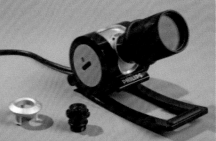
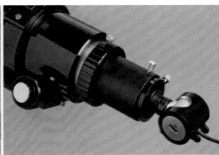

this purpose, you insert the knife's edge between the pivotable tube and the fixed part of the webcam body (see example on previous page). Take care not to sever or break the three plastic clips that attach the tube to the camera body. After the tube is removed, the lens can easily be unscrewed from the holder, and the respective webcam adapter can then be attached. One end of the adapter is then screwed into the lens thread of the camera, and the 1.25" tube on the other side is plugged into the focuser of your telescope. This adapter does not contain any lenses, thus the imaging sensor of the camera is placed in the primary focal plane of the telescope to generate a sharp image. Instead of the telescope's eyepiece, the webcam is simply plugged into the focuser. If you are using the eyepiece projection method, the webcam body with its adapter is placed directly into the eyepiece projection adapter, after this has been equipped with an eyepiece and plugged into the focuser.

The First Test Video Through the Telescope

During the daytime, aim your telescope at any object and switch off the motor drive of the telescope tracking. A power pole, a treetop, or a distant building make for good test objects. Then mount the webcam to the telescope. Try to place the desired object in the field of view of the webcam and focus on it. You will quickly recognize how tiny the field of view is, which is related to the small size of the imaging sensor. If you put an eyepiece into the focuser first, it will be easier to place the desired object precisely at the center of the field of view.

Next, replace the eyepiece with the webcam and start the automatic exposure. You should already recognize the targeted object on the screen even if it is still out of focus. Focus using the fine focus on the focuser until the image on the computer screen is pin sharp. Depending on the temperature, the air might scintillate, which would make the focus setting more difficult. Such conditions provide a good test for "the real thing," because while imaging planets at night you will sometimes have to contend with

Full field of view of the camera. *Reduced field of view.* *Parfocal eyepiece with tape as marker.*

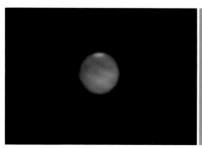
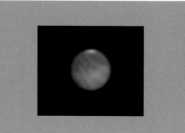
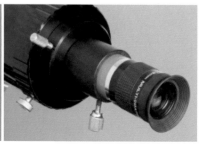

strong air turbulence. After you have found the best point of focus, switch off the automatic exposure again and try to achieve a better image result with the manual setting of the exposure parameters.

Parfocal Eyepiece for Focusing

An eyepiece that is "parfocal" to your webcam can be rather helpful for future applications. This means that the eyepiece, as well as the webcam provides a sharp image in the same focus position. For this, you remove the webcam from the focuser after having focused, and put your eyepiece back in: Then, focus the image by sliding the eyepiece up and down in the focus tube without clamping. The position at which the image appears sharp in the eyepiece needs to be marked with a piece of tape that you attach to the eyepiece tube. While doing the aforementioned, make sure that you do not modify the position of the focuser.

The best solution, however, is a clamp ring that can be locked in the proper position with screws in such a way that the ring rests against the focuser. It is a good idea to take a quick snapshot of the set-up: The position of the focuser will be clearly visible in your snapshot, and thus can be referred to for quick reconstruction in future imaging sessions. Equipped with an eyepiece prepared in such a way, you can later center the object first and then focus on it. If you now replace the eyepiece with the webcam, the rough focus point should already be achieved, leaving only minor corrections to be performed.

The First Exposures with Your Webcam

By now, you have gained enough experience that you are ready to try your first exposure of a planet. For this, the equatorial mount of your telescope should be properly polar-aligned, so that the subject does not drift out of the small field of view during the exposure.

Telescope and Webcam Set Up

Aim your telescope at the targeted planet using an eyepiece of medium magnification. Afterwards, place a Barlow lens in the optical path to increase the focal length. With the addition of an extension tube behind the Barlow lens, you can further increase the magnification.

If you are working with the eyepiece projection method, after positioning the telescope, replace the eyepiece with an eyepiece projection adapter, which is plugged into the eyepiece and attached to the webcam.

Position the Object

Next, target the planet with your parfocal eyepiece, position it exactly at the center of the image, and then focus the image. If you now place the webcam in the focuser instead of the eyepiece (possibly using a UV/IR blocking filter), you should detect a blurred bright spot on the screen of your computer.

In this phase, you should use the full sensor area (640 x 480 pixels); otherwise, the limited field of view will make it difficult to locate your subject. If no planet is visible, set the exposure to manual, move the controls for brightness and gain to the maximum on the right, and the exposure to the maximum on the left (longest possible exposure time). Now the planet should appear as a bright area. If not, use the eyepiece again to precisely center the planet. With some practice, you will soon master the challenge of centering the planet on the tiny sensor of the webcam.

Astrophotos with a Webcam	
1.	Aim at the planet, add a Barlow lens–if necessary add an extension tube
2.	Center and focus the planet with a parfocal eyepiece
3.	Screw a UV/IR blocking filter into the telescope adapter
4.	Place the webcam body with the telescope adapter in the focuser
5.	Center the planet using the fine control (1x) of the telescope
6.	Set the exposure, image gain, and gamma value
7.	Focus the image with the focuser in accordance with the computer monitor
8.	Set white balance for ideal color
9.	Set frame rate to 10-20 frames per second
10.	Reduce the field of view for planets to 352 x 288 pixels
11.	Start exposure
12.	Check tracking
13.	Take several videos with various settings
14.	Document all settings

Centering and Exposing

Now, center the planet with the finest movement available on your telescope control. Select the correction speed 1×, i.e., sidereal speed. Higher speeds will cause the planet to move out of the field of view, and your

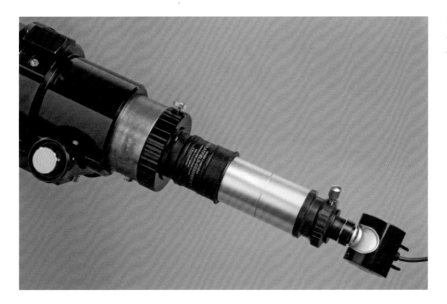

Webcam at the telescope, in front of it is a Barlow lens with variable extension factor.

search will have to start over again. Once the object is centered in the field of view, you can once again set the exposure to automatic.

After a short time the planet is visible in its outlines. Since it occupies a small area compared to the field of view, it will be heavily overexposed. In the next step, you switch back to the manual exposure setting and reduce the exposure time, brightness, and gain until the planetary image does not exhibit any washed out, saturated, or overexposed areas.

Focusing

Next, set the ideal focus on the focuser of the telescope, exercising the utmost care. At this point, the slightest rotation of the focus wheel will substantially affect the focus of the image. In addition, you need to ensure that the focus modification does not cause any "shifting", i.e., the offset of the field of view caused by tilting the main mirror during focusing. Should the planet still move out of the field of view during focusing, you need to retrieve it again with the fine movement buttons of your telescope control. That can be rather cumbersome. Image shifts during focusing are commonly encountered with the use of telescopes of the Schmidt-Cassegrain design, where focusing is carried out by shifting the main mirror. If you are encountering these problems, which cause focusing to become a burden, it is helpful to mount an

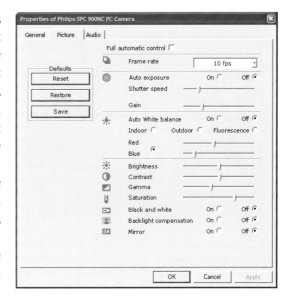

Top–The planet Mars;
Center–appears more focused;
Bottom–improved exposure/color balance.

additional shifting-free focuser, available as a separate accessory, between the telescope and the camera.

Set Coloring, Field of View, and Frame Rate

After setting the focus and the selection of a proper exposure time, the planet should be distinctly visible on the computer screen. You will be able to see the parallel cloud bands on Jupiter, the ring with the Cassini division on Saturn, as well as the dark areas and possibly the white polar ice cap on the red surface of Mars. Venus will present itself white and without structures, but will display a distinct phase between an almost round sphere and a small crescent. The live image on the monitor will–comparable with the view through the eyepiece–jitter, swirl, and jump back and forth, sometimes focused, sometimes not. You do not need to worry about this, because with the proper software, you will later automatically select those single frames that have an ideal focus. This is the trick when working with a webcam! Only on nights with extreme air turbulence, i.e., bad seeing, are planetary images not worthwhile.

Pay attention to the planet's natural color, which is already noticeable during the exposure. You can optimize it through the manual setting of the white balance. Select a frame rate of 10-20 images per second for the first exposure, and reduce the field of view to 352 × 288 pixels (see also page 45).

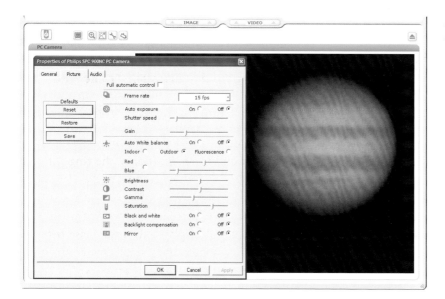

Example of an appropriate exposure of Jupiter.

Start the Exposure

Now you can start the exposure! In the meantime, you will still see a live image on the screen, where you can check to see if the planet remains centered. If required, perform minor correction movements with the telescope control. Do not let the planetary disk move too close to the edge of the field of view. Finish your exposure after 2-3 minutes at most, so that the file size and subsequent processing time is kept within limits. In this manner, you also avoid blurring caused by the rotation of the planets Mars and Jupiter.

Settings and Documentation

If you are slightly uncertain regarding the focus and exposure settings, just record several videos using various settings; but do note which parameters you changed and how you changed them. Assign a new file

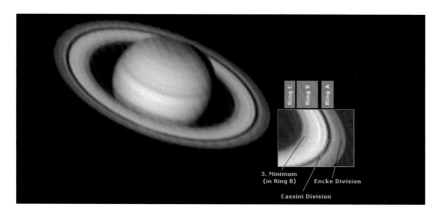

The planet Saturn with ring details.

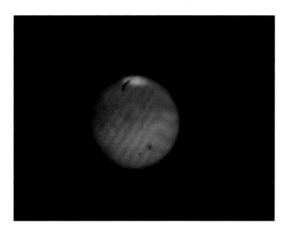

Dust particles distract in this Mars image.

name for each video sequence, ensuring that videos that have already been saved are not overwritten. This documentation is necessary, because your selected settings such as exposure time, white balance, gain, and contrast are not entered as information in the video file itself. Only if you can reproduce the settings that led to a better result, can you profit from your experiences during the next imaging session. However, it is not recommended to simply accept parameters which once proved to be good, without checking and making the necessary modifications.

Tips for the First Exposure

A well-suited object is the Moon, with the exception of the days around the full or new Moon. Take exposures at the shortest possible focal length (500 to 1000 mm). Use a focal length reducer, if you have one available (i.e., a Shapley lens).

At first, observe the entire Moon through an eyepiece. Then select a rather intriguing area, that you would like to image with the webcam. Change the exposure parameter until the live image on the screen looks good. Use a low frame rate (5-10 frames per second) and record the exposure for two minutes. With the help of the software Registax (see pages 54,142) you can process a layered image or select the sharpest single frame.

Depending upon the object and conditions, you must always readapt these settings. Overexposures, which result in fully saturated pixels, need to be avoided at all costs, because washed out image areas caused by overexposure cannot be "saved" through later image processing (see figure, page 26). With the bright Venus you can reduce the exposure time in order to avoid overexposures, whereas with Saturn you might prefer to use a higher gain in order to capture the gray shimmering C-ring. Fluctuations in the apparent magnitude of the planets throughout the course of weeks and months, during changing weather conditions, or a different height above the horizon, need to be considered, as well, for the selection of the exposure settings. But do not become discouraged. By controlling the live image on the computer screen, and with some experience you will soon be able to find the proper settings quickly and reliably.

Tips and Tricks

Seeing and exposure time: If the seeing is good, you can expose a little longer and reduce the gain instead, which also lowers the noise (see also figure, page 49). If the seeing is bad, shorten the exposure time and increase the gain.

Sensor cleaning: If small black dots or short lines are visible on your images, you need to clean the sensor of your webcam. Moisten a Q-tip with pure alcohol and wipe carefully, without much pressure, over the sensor. Wipe again with the dry end and, if necessary, blow off any lint. Clean the sensor as rarely as possible, and always close the webcam body with the telescope adapter and screwed in UV/IR filter to protect the sensor from becoming contaminated.

Daylight exposures: If you are using the webcam for daylight imaging, i.e., the Sun with appropriate filters or Venus, you might receive a low-contrast image because light entered through the camera body and reached the sensor. You can remedy this by wrapping the camera body in a piece of aluminium foil, thus shielding off the stray light.

Processing Your Webcam Images

You now have a planet video with hundreds or thousands of single frames on your hard disk. In the following section, you will learn, step-by-step, how to create a sharp and detailed planetary image.

The Processing Steps

Your planet video is saved in the AVI format on your hard disk. It contains many single frames that all differ from each other and that contain differing amounts of noise. If you play back the video in a player (e.g., Microsoft Media Player) and suspend the viewing with the *Pause* button, you can unhurriedly examine the single frames. But do not be alarmed–the images often appear unfocused and lacking in details, due to the image noise. Only the continuous video lets you sense the abundance of information that is available in the images as a whole. Image **1** shows examples of a good and a bad single frame. It is now the task of image processing to compile this information into one single image. Essentially, the processing is divided into the following four parts:

1. Selection of the best single frames and discarding of the unfocused ones

2. Precise stacking and averaging of the selected images

3. Sharpening

4. Fine tuning (e.g., in Photoshop)

1 A good and a bad single frame from the movie of a Philips webcam.

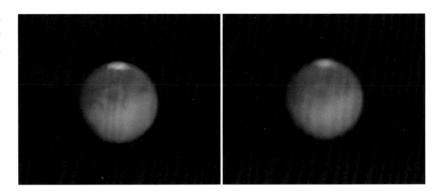

In particular, items 1 and 2 are time consuming and laborious. Fortunately, software is available to handle this task. You will find a description below of about how to proceed with the software Registax V4, which is available on the Internet as freeware.

The web address for the download of Registax V4 is: http://www.astronomie.be/registax/. The version that is described in this book is 4.0.1.1 (later versions may differ from this). You can reproduce the illustrated processing steps on your own PC, if you download the planetary video from http://www.astromeeting.de/astrophotography_digital.htm. The video features an image of the planet Mars from August 2003, taken with a 10-inch telescope and a Philips webcam.

Image Processing in Registax

It is assumed in the following description, that you will run the program Registax for the first time, and have not yet changed any default parameters. If default settings need to be changed due to image processing, this will be explicitly stated. In all other cases, the default values recommended by the software will be accepted. If you are unsure, compare the parameters on your screen with ones included in the screenshots.

After the download, installation, and first start of the program you will see the start screen:

Instead of menu commands, you find small tabs in Registax with the terms *Align*, *Optimize*, *Stack*, *Wavelet*, *Final*, and *About*. These tabs simultaneously represent the progress of the image processing, which proceeds from left to right. Only those tabs that are green in color can be selected. In the beginning stage, for example, the red-colored *Optimize* tab cannot be selected because it is not possible to take the second step before the first.

Begin by selecting the video file that you want processed. For this, click on the *Select* button that is located above the *Align* tab. An *Open file* dialog appears, where you choose *Video (*.avi)* as the file filter. Then select the respective video file from your hard disk and confirm with *Open*.

Registax opens your video file and displays the first frame. At the bottom of the window you can read, for example, *Frame (1): 1/800*, which means that this particular file includes 800 single frames, the first of which is currently displayed. Above this display, you can find a line with a slider at the very left position. If you drag this slider to the right with the mouse, you can examine each frame from the video individually. To access a specific frame you can also enter its number into the bottom right field *Go to Frame*. Try it and jump to image number 341, a particularly sharp single frame from the video. In comparison, number 155 is rather blurred due to seeing effects.

It is now your task to select an exceptionally sharp image out of the 800 single frames, which will be used as the reference image. Here, it is not necessary that you pick the

sharpest one out of the 800, but simply one that appears sharp and detailed to you. For our purposes, let us agree on image number 341. Now you let the software identify the quality of all single frames, compare them with the reference image, and stack them precisely.

At first, it is important that you set the proper size in *Alignmentboxsize*. It should be large enough so that the planet fits completely within it, or at

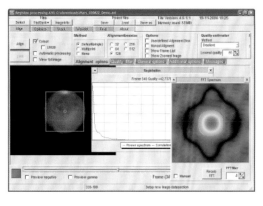

least so that no large parts of it are located outside of the box. In our case the size 128 is sufficient. Center the planet within this box and click on it with the left mouse button.

Two new windows will open (*Registration* and *FFT Spectrum*). In addition, the button *Align* in the top left corner is now clickable (green in color).

Click on *Align* and watch Registax at work. Depending on the computing power of your PC, it might take a while until all 800 images are aligned respectively. Finally, you will see the result, as shown in the screenshot at left.

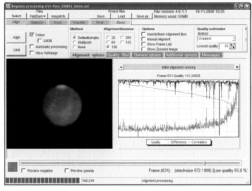

The Registax software evaluated each frame and changed the sequence of the single frames so that the particularly good ones are shown on the left, and the notably poor ones are on the right. Take a close look at the window *Initial Alignment Running*. It displays a red curve that falls off towards the bottom and documents the quality of the single frames. The green curve displays the difference of the individual images to the selected reference, (in our example, image number 341). As quality decreases, the differences increase; therefore, the green curve ascends to the right. The blue curve, however, indicates location displacements. If the planet jumps back and forth due to poor seeing, this curve points downwards. The fact that the planet changed its position in the image does not necessarily signify that the image quality is lower. Therefore, the course of the blue curve is not particularly important for the evaluation of image quality.

Drag the slider at the bottom of the window back and forth with the mouse, and notice how a green double line responds accordingly. With this you determine which images are used for the averaging, and which images will be discarded. Only those images to the left of the double line will be used. If you only use a few images, their quality is indeed superior, but it is best to use as many images as possible in order to reduce the noise. In this case, therefore, you select approximately two thirds of the 800 single frames, discarding one third. Thus the position of the green line needs to be selected as shown here (bottom-left screenshot).

Note: If you are still uncertain about this, then don't change anything. Instead, rely on the quality limit selected automatically by Registax. In

either case you need to confirm your selection by clicking on the button "Limit".

After this, Registax jumps automatically to the next tab "Stack". Now it is getting interesting, because in this step Registax will generate a single, final image averaged from your selection of the best single frames. Click on the button "Optimize & Stack" to start this process. This procedure is also quite resource-intensive and will take some time. During the process you will see the screenshot at right, labeled "Stacking".

After this step is completed, Registax moves automatically to the next tab *Wavelet*, and displays the calculated final image. You might be a little disappointed when viewing it, because at the moment, it doesn't appear to be as sharp as your initially selected reference image. However, it seems to be much "smoother", since the adding procedure greatly reduced the noise. And it is this, which allows you to apply image-sharpening algorithms. The unsharpened image is shown here (at right).

The bar on the left displays six different filters called 1:1, 2:1, on up through 6:1. Start with the topmost filter (1:1) and drag the slider slowly to the right with the mouse. Only if you release the mouse button, will the effects of this filter be visible on the planetary image. Notice how details become increasingly visible on the planet's disk, the further to the right you go. But, don't overdo it or you will produce unpleasant artifacts. To visualize this, just move the slider of the filter all the way to the right (Value: 100) while paying attention to the edge of the planet's disk where a double contour emerges, which in fact does not exist. Thus, you should reduce the filter effect until the slider is located approximately at the position 30. Next, move the second slider from the top (2:1) to the right, until it reaches the position around 20. The slider 3:1 is set to nine. Now the Mars image as shown here (3rd-right) is already quite impressive.

If you got carried away with experimenting and modified many settings, but did not achieve a presentable result, you can start over, just click on *Reset*. The individual filters can also be moved to the negative range on the left.

Keep in mind that the above-mentioned sharpening parameters are appropriate for this particular Mars video. However, the settings are strongly dependent upon the nature and quality of the exposures. If you are later processing your own videos with Registax, these same settings may not provide the best result. Just experiment with various filter positions until you achieve the optimum result. In time, you will develop a sense for the best procedure for your own images.

Note: Before saving, you must click on the button *Do All*, because Registax initially only applies the wavelet filters to a central area, to save computing time. Only after clicking on *Do All* will the sharpening filter be

applied to the entire image area. This needs to be considered particularly for larger image formats.

You can save the sharpened image by clicking on the top left button with the red text "Save Image". Clicking on it will open a dialog window:

It is imperative that you select "TIFF(16BIT*RGB)" as *File Filter* because the TIFF format allows a lossless storage of the image file, unlike JPEG.

Fine-Tuning in Photoshop

You can perform the final fine-tuning in an image-processing program of your choice. In fact, Registax allows adjustments for contrast, tonal levels, and color balance, but you might be more familiar with these processing steps in your favorite program. For our example, we will use Photoshop.

Open the final image in the TIFF format in Photoshop. The Mars image is already rather appealing, so that further processing steps should be applied carefully.

Color Saturation

The color saturation should be increased slightly. For this, you select the command Image>Adjustments>Hue-Saturation and move the slider for *Saturation* until it reaches the value +15.

Color Adjustment

The Mars image appears to be slightly too red. Therefore, you perform a minor color correction in the next step. The menu command Image>Adjustments>Color Balance leads you to the following dialog window, where you move the topmost slider in the direction of *Cyan* until it reaches the value −20. Make sure that *Midtones* is selected and that the option *Preserve Luminosity* is checked as shown below.

The result is a color-balanced display of the Mars surface, which corresponds with the visual impression as seen through the telescope. The dark regions on Mars now show the typical, slightly greenish color; the ice of the polar cap appears as pure white; and the bluish haze around the north pole is also rather impressive (at the bottom of the image).

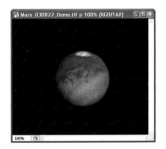

Final processed image

Contrast Adjustment

Now, you'll increase the contrast very slightly by selecting the command Image>Adjustments>Curves. When the dialog window appears, the default *curve* is displayed as a straight line at a 45-degree angle. You can modify the contrast by changing the linear curve progression. Do this by clicking on the diagonal line with the mouse to create an adjustment point, and then drag the generated point upward or downward. Here, you will create two adjustment points to apply a slight S shape to the curve's form. With this, you reduce the dark tonal values and increase the brighter tonal values (see screenshot, top-right).

You did it! An increase in contrast is the result and, it is simultaneously the completed final result of the image processing. Remember to save the finished image.

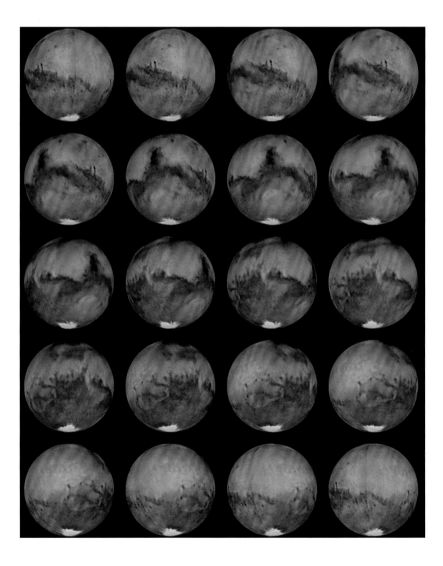

Twenty exposures taken over the course of several weeks, showing the entire Mars surface.
With the help of specific software (see page 141) you can create a movie from this.

Chapter 4
The Digital Single Lens Reflex Camera

Application Areas of a Digital Single Lens Reflex Camera

A digital single lens reflex camera (DSLR) is, on many accounts, the ideal camera for astrophotography beginners. With this camera you can take beautiful scenic shots, as well as impressive pictures of the Sun, the Moon, and even deep-sky objects.

Characteristics of a DSLR

The single lens reflex camera uses a mirror to direct the light from the lens onto the focusing screen. Thus, (as opposed to a compact camera) the photographer views the subject through the same optics as those used for the exposure.

DSLRs are enjoying increasing popularity in everyday photography, as well as in astrophotography. This is not surprising since, owing to their interchangeable lenses, they can be applied to many diverse situations while providing high image quality. Due to the capability to remove the lens, they can also be attached to most telescopes.

A DSLR is the ideal camera to capture the Northern Lights. It is flexible and ready for quick use.

Appropriate models cost around $600 (body only); and top-of-line models cost several thousand dollars, but are not necessarily better suited for astrophotography.

Suitable Photo Motifs

Without a Telescope

During dusk you can take nice scenic shots with a DSLR and a tripod (if necessary). Be it a gorgeous sunset, a close encounter between the thin crescent Moon and Venus, or the rise of the red Mars between trees in the east: with a DSLR you will not miss these scenes. The quality of a DSLR camera, along with a first-class lens, is so high that they provide all that can be desired in regard to sharpness. Interchangeable lenses, as well as zoom lenses, allow different angles of view of your desired motif.

However, the potential of such a camera is by no means exhausted by nice scenic shots, which are in fact not its main area of application. A DSLR is by far the best choice for capturing high-quality images of short-lived events that require quick reactions, such as the Northern Lights, a halo effect, or the culmination of a total solar eclipse.

With a Telescope

This does not mean, however, that you have to put away your DSLR after nightfall. Equipped with a camera lens and mounted piggyback on an equatorial telescope, you can produce long exposures of whole constellations with a relatively large angle of view. With a little perseverance you can thus create your own photographic atlas of the constellations within the course of a year. In this way, you can also produce detailed images of the Milky Way, as well as lucky shots that capture shooting stars.

If you remove the lens of the DSLR and replace it with a telescope adapter, you can use the telescope as a lens. This allows you to take frame-filling pictures of the Sun (do not forget to use appropriate solar filters, see page 6) and the Moon, as well as star clusters, nebulae, and galaxies. Many of these so-called deep-sky objects are bright enough and thus, are a worthwhile target for a DSLR.

The annular solar eclipse from October 3, 2005–a composite of single frames.

Brocken specter: The sun shining from behind, projects the observer's own body onto the fog.

Advantages and Disadvantages of a DSLR

+ Flexibility and Simple Handling

Compared with a CCD camera, which is specifically designed for astrophotography, the simple and mostly intuitive operation of a DSLR is a big plus. Many photographers are also already familiar with its operation through regular daytime photography. The DSLR cameras have a viewfinder that allows the photographer to evaluate the angle of view, as well as the sharpness of the image directly through the imaging optics.

All possible settings can be performed on the camera body, and just as with the compact camera, the exposed images are stored on a memory card. This means that the operation of a DSLR on a telescope can basically be carried out without the need of a computer or laptop. The image files can be transferred to a computer at a later time. The most distinguishing characteristic of the DSLR cameras, and what sets them apart from compact cameras, is the fact that they have removable lenses. In fact, the wide range of lenses available for DSLRs turn this type of camera into an all-arounder. In addition, the DSLR offers much longer exposure times than compact cameras.

+ Color Images

A long piggyback exposure of the constellation Scorpius.

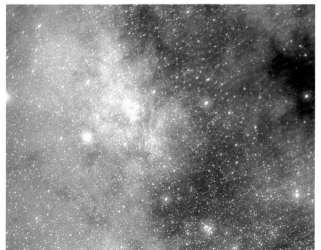

DSLR cameras contain a sensor that records color images in a single exposure. Thus, you do not have to worry about applying red, green, and blue filters for creating color images on the computer later, as you do with special astronomical CCD cameras. However, this "single-shot color capability" comes at the expense of reduced light-sensitivity and image resolution, as compared to a monochrome image sensor.

+ Large Image Sensor

A great benefit of the DSLR is the size of its image sensor. Even professional models with sensor sizes within the range of the 35mm format (24 mm × 36 mm) are becoming more affordable.

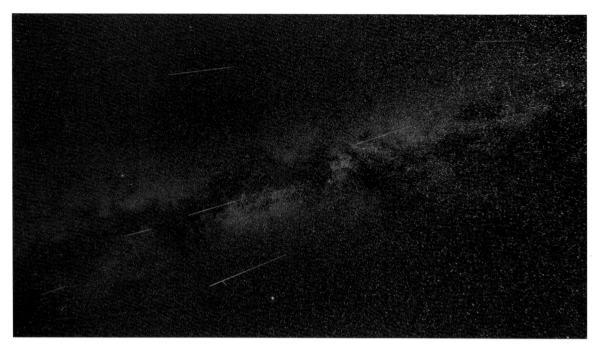

Regardless of which DSLR model you decide upon, it will have a much larger exposure area (sensor) compared to compact cameras and many astronomical CCD cameras. This means that, in combination with the usual focal lengths of amateur telescopes, larger celestial objects will fit in the frame without getting cropped. You just need to make sure that your camera's optics can evenly illuminate the format of your image sensor so that your image does not suffer from dark corners caused by vignetting, or out of focus stars lying outside the center of the image caused by image distortion and/or an uneven field (see page 23).

Shooting stars against the backdrop of the summer Milky Way.

+ Control Monitor

An essential advantage of a DSLR is the LCD monitor that is found on the rear of the camera. This allows you to immediately examine your results after the exposure. If desired, a zoom function on the LCD monitor shows image details in high magnification allowing you to identify even small errors, which you can thus avoid on the next exposure. The flawed images can simply be deleted to free up valuable disk space.

View of the sensor of a DSLR with a US penny as comparison.

+ Documentation

A valuable feature of a DSLR camera is its ability to save important data for each image such as shutter speed and ISO speed, as well as date and time of the exposure. This helps tremendously in the necessary task to record all exposure parameters for each astrophoto.

However, keep in mind that the camera cannot save every relevant piece of data. Therefore, you should make notes of items such as employed focal length and configuration of your telescope; targeted object, filters used, and guiding details; as well as atmospheric conditions (sky quality, seeing, temperature, location) so that you can review these details at a later time.

+ Advantages Compared to Film

Compared to working with a 35mm film camera, you have quicker success with a DSLR due to the instant review capabilities. Other advantages include lower supply costs; a completely flat camera sensor as opposed to the slight curvature of 35mm film; and the ability to freely select the ISO speed for each individual exposure, which, in an analogue camera can only be achieved by switching the roll of film. Although one might assume that a very high ISO speed would be optimal for faint astronomical objects, this high sensitivity comes at a price. Whereas higher sensitivity with regard to film leads to grainy images; higher ISO settings in digital cameras result in increased electronic noise. Thus, it is important to find a compromise

Camera with control display and rotating right angle finder.

A DSLR saves important exposure data for each photo.

between a high ISO speed on the one hand, and the least amount of noise on the other hand.

– Thermal Noise

In general, the CMOS (complementary metal oxide semiconductor) image sensors that are used in DSLR cameras exhibit little thermal noise, especially when compared to compact cameras. Yet, this advantage is lessened by the fact that the image sensor–unlike the astronomical CCD camera–is not actively cooled. This limits the maximum exposure time to 10-20 minutes, depending on the actual ambient temperature. With longer exposure times the thermal noise increases dramatically. However, this limitation can be circumvented by stacking several short exposures, and thus should not be considered a real disadvantage.

– High Power Consumption

The relatively high power consumption of a DSLR during long exposures can cause problems for astrophotography. In particular, during cold weather, batteries may only last for an exposure time of an hour or an hour and a half. You can remedy this by having a spare battery available or with an external power supply.

– Eyepiece Magnifier Preferable

The focusing control on a DLSR is only suited for manual focusing of limited applications. However, when operated on a telescope, the camera's focus must be accurate to a fraction of a millimeter. Therefore, you should use an eyepiece magnifier, a right angle finder with magnification (see figure on left), or specific focusing software. But, the latter requires operating a computer or laptop close to the telescope.

– Resolution Loss Through Color Capability

When compared to a CCD camera, the respective characteristics of the DSLRs image sensor are a disadvantage. In order to produce color images with a single exposure, the individual pixels of the sensor are covered with a regular pattern of tiny filters of different colors.

Four pixels are required to record a brightness value for the primary colors red (1x), green (2x), and blue (1x), respectively (see pages 97-98). Due to this, the effective resolution is reduced. In fact, a luminance channel (black and white image) in full resolution is calculated from the color values, but this interpolation technique is no real substitute for an image sensor that only records brightness values but no colors. Currently, these monochrome sensors are only used in dedicated astronomical CCD cameras.

– Lower Dynamic Range

Another limitation of a DSLR in comparison to specific astronomical CCD cameras is the A/D (analog/digital) conversion of the obtained image information. In the RAW format, DSLRs save "only" about 12 bits per color channel, which–in theory–translates to 4,096 different shades of red, green, and blue. Although this number seems high, it is rather low compared to an astronomical CCD camera, which uses a 16-bit conversion rate and thus provides 65,536 theoretical brightness levels. In practice, this will be most noticeable with high-contrast motifs, for example a bright nebula with increasingly fainter outer areas. If confronted with such a subject, a DSLR might not have the capacity to image the bright center and the faint outer details. In such a case, only a combination of long and short exposures (to capture the nebula's faint details and the bright center, respectively) will help you to produce successful images with your DSLR.

– Limited Red Sensitivity

Many hydrogen nebulae emit bright red light of the so-called hydrogen-alpha wavelength. Unfortunately, most DSLR cameras do not record this light very well, and thus you need comparatively long exposure times to record it on the image. The cause for this is an infrared blocking filter that is located in front of the sensor of these cameras, and which not only blocks the infrared light, but also the hydrogen-alpha light. This "red blindness" of DSLR cameras is detrimental to many deep-sky objects. However, this shortcoming can be remedied; the blocking filter in front of the sensor can be removed or replaced by a different filter. Very brave photographers remove the filter themselves!

A DSLR cannot record very bright and very faint areas at the same time

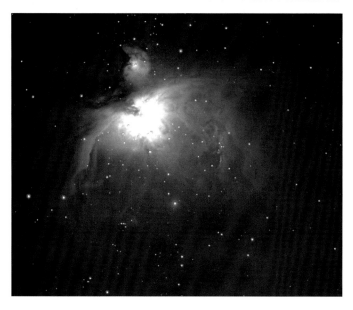

However, if you do this this, you will lose any existing warranty and you will no longer be able to use the camera for regular daytime photography. This "surgery" also breaks the autofocus since the length of the optical path will have been changed. Hutech, a company in California, offers modified DSLR cameras on which the filter in front of the sensor is either removed or replaced by a filter fully suitable for astrophotography. The special model EOS 20Da from Canon is also specifically designed for astrophotography and it records hydrogen-alpha light much better than the production model EOS 20D (see page 71).

– In-Camera Image Processing

Certain image editing tasks that are already performed within the camera and that cannot be switched off are not useful for astrophotography. For normal daylight photography, it may be helpful to "preprocess" and improve the image; for astrophotography this can be rather annoying. It is helpful though if a camera can provide a true RAW (i.e., uncompressed) image, which unfortunately, not all models do. Only the dedicated astronomical CCD cameras provide truly unmanipulated data after reading out the image sensor.

Conclusion

All the disadvantages that were previously mentioned should not prevent you from using your DSLR for astrophotography. In light of the cost, a DSLR is truly the ideal camera for beginners, as well as for more advanced users. Many of the disadvantages only become obvious and relevant after some intensive astrophotography work. And more importantly, the small deficiencies will not keep you from achieving impressive results with your DSLR.

You can find a direct comparison of the application areas of the different camera types in the Appendix.

The Digital Single Lens Reflex Camera

+ Advantages	– Disadvantages
Easy to use	Relatively high noise during long exposures
No computer necessary for photography	High power consumption
Versatile application	Difficult focusing of astronomical motifs on the focusing screen
Color images provided	Due to color information, lower resolution than a black and white CCD camera
Suitable for large objects	Limited red sensitivity through IR blocking filter
Results can be reviewed instantly	In-camera image processing that is detrimental for astrophotos
Automatic data documentation	
Flat exposure area as compared to film	
Easy adjustment of ISO speed	

Buying Tips for DSLR Cameras and Accessories

DSLRs are more expensive, therefore, it makes sense to carefully consider which camera is suited best for your purposes before the actual purchase.

Tips for the Camera Purchase

DSLR cameras are available from Canon and Nikon, as well as from a host of other manufacturers. Canon and Hutech even offer models made especially for astrophotography, which are superior to the production models when recording the red light of many emission nebulae. The Canon EOS 20Da offers a live view on its LCD monitor, which helps tremendously with focusing.

Before buying a DSLR camera you should ensure that your telescope optics are able to optimally illuminate the format of the image sensor: The larger the image sensor of the camera–the more difficult this becomes. An expensive camera with a "full format sensor" cannot leverage its potential for astrophotography if your telescope only illuminates a small central part of the image circle. The image circle that is illuminated properly by a telescope is dependent upon the design of the telescope. In combination with focal reducers (i.e., Shapley lens) the illuminated image circle is reduced even more, whereas it is enlarged when systems for focal length increase are used (i.e., Barlow lens).

Before you decide on a camera, thoroughly compare the technical data of the various models.

Different DSLR models from left to right: Canon EOS 5D, Canon EOS Digital Rebel XT, and designed specifically for astrophotography the Canon EOS 20Da.

The Veil Nebula in Cygnus. Exposures taken with the same exposure time: on the left a Canon EOS 20D production model was used, on the right the modified astronomical model Canon EOS 20Da.

Useful Accessories

With DSLR cameras you have the option to buy the body only (without a lens). But, in order to use a DSLR for astrophotography additional accessories are required.

Memory Card

A memory card is, in a way, the replacement for classical film. Most DSLRs that are employed for astrophotography use a memory card of the Compact Flash type. If you opt for a two-gigabyte memory card, you will be well prepared for your astrophotography sessions. All images taken during one or more nights will easily fit on such a card.

Remote Controller

Just as with compact cameras, you also need a remote controller (with cable or wireless) for your DSLR. This allows you to release the camera's shutter without touching it, thus avoiding camera shake.

Eyepiece Magnifier or Right Angle Viewfinder with Magnification

The regular focusing screens of most DSLRs are not well suited for the manual focus of faint objects.

DSLR with accessories, from top left clockwise: AC adapter, 2-inch adapter, right angle finder (top right), spare battery, memory card, T-ring, Timer Remote Controller.

Therefore, manually focusing astronomical subjects can be a challenge. An eyepiece magnifier is a tremendous help here, because it provides a magnified view of the focusing screen.

Additonal Power Supply

DSLRs use a lot of power during long exposures. If you want to avoid the frustration of dead batteries in the middle of an imaging session, it is advisable that you invest in additional power supplies, such as a 110V power adapter, a 12V adapter, or extra batteries for your camera.

T-Ring

A T-ring is used to connect the camera to the telescope. The bayonet mount found on one side can be attached to the camera body. The standard T-thread found on its front can be connected to corresponding adapters. T-rings are available for specific camera types, such as Canon EF or Nikon.

2-Inch Adapter

This adapter threads onto the T-ring on one side and the focuser of your telescope on the other.

IR/UV Blocking Filter, Coma Corrector (If Required):

If you are planning to take exposures with a refractor, you should consider buying a 2-inch UV/IR blocking filter (see page 22). If you are using a Newton telescope, you might have to employ a coma corrector in order to capture pinpoint stars all the way into the corners of your image (see page 107).

Budget

The table on the next page shows a sample purchase price including the camera body. All prices are reference values (June 2007); products from other manufacturers may vary in price. The calculation excludes the following items, assuming that they are already available: a telescope on an equatorial mount offering the capability to make fine adjustments; a guide scope with a reticle eyepiece; a computer with sufficient disk space, image processing software, and backup devices.

Snapshot with a DSLR: A fragment of a circumhorizontal arc showing in the contrails of a plane.

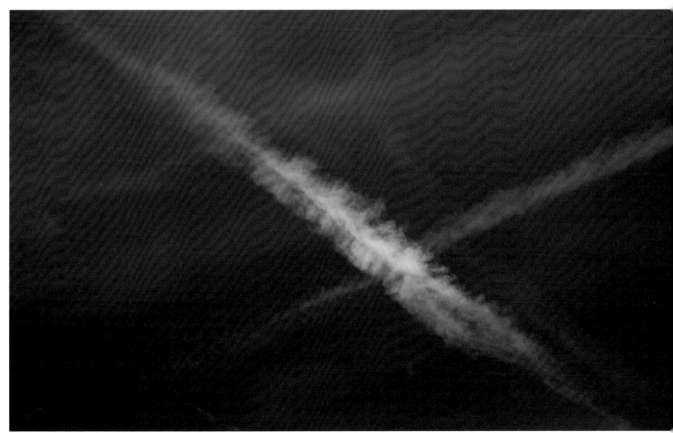

Sample Calculation for a Starter Package		
Canon Digital Rebel XT body	$	550.00
2 GB Compact Flash memory card	$	35.00
Canon Timer Remote Control	$	133.00
Canon Right Angle Finder with magnification	$	180.00
Canon NB-2LH Lithium-Ion Battery	$	50.00
T-ring for Canon EOS	$	20.00
2-inch Adapter	$	32.00
Total	$	1000.00

Taking Astrophotos with a DSLR

Astrophotography with a DSLR is done primarily with the following two setups: Piggyback on a tracked telescope or through the telescope itself, thus using the telescope as a camera lens.

Piggyback on the Telescope

If you want to image larger celestial areas with long exposures, you can mount your camera together with a wide-angle lens and a remote controller on your telescope. For this, the telescope should be equatorially mounted and tracked by a motor drive.

With this setup, the telescope itself acts as a guide scope. Aim at a star close to your imaging area through an illuminated reticle eyepiece, and check if the drive of your mount works accurately. If you notice divergences, correct them using the mount's hand controller. These minor adjustments will not be noticeable on the image, because the focal length of the telescope is usually much longer than the focal length of the camera's lens.

When mounting the camera onto the telescope, please make sure that it is attached firmly and securely. The camera must not move on its mounting during the exposure. Another setup option is to attach the camera to the counterweight bar of the mount using a special camera clamp.

But such a solution only makes sense if the counterweight bar follows the rotation of the telescope along the declination axis. This, however, is not the case for all mounts.

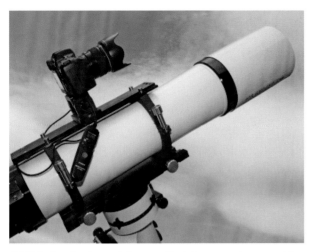

A DSLR piggyback on a telescope, the telescope acts as a guide scope here.

Piggyback setup using a plate system and tube clamps for heavier lenses.

Clamp for attaching the camera to the counterweight bar of the telescope mount.

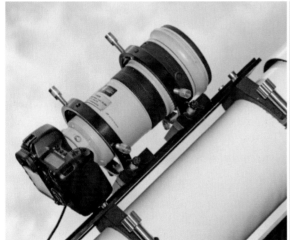

Tips for the First Photos

For piggyback photos, constellations and details from the Milky Way are a good choice. Lenses of all focal lengths are suitable for the beginner; from wide angle to a maximum of 200 mm. Lenses with a fixed focal length are better suited than zoom lenses.

Choose "Daylight" for the white balance setting of your camera. If necessary, guide your exposure manually, employing a reticle eyepiece on your telescope. Use a maximum exposure time of 5-10 minutes with a large aperture (smallest f-stop) and an ISO speed of 400 or 800.

To achieve the best focus you can set the autofocus on the Moon or distant city lights. Switch off the autofocus afterwards and–if you are using a zoom lens–do not change its focal length.

For these pictures, you can use older SLR lenses as well, provided you find the right adapter to fit your DSLR. The loss of the autofocus function and the automatic aperture control is irrelevant for astrophotography.

Photography Through the Telescope

If you want to take full-frame pictures of nebulae, star clusters, and galaxies, you need to use your telescope as a lens. For this purpose, the camera, instead of an eyepiece, is placed on the telescope.

Mounting the Camera to the Telescope

In order to mount the DSLR on a telescope you need the above-mentioned T-ring, which has a bayonet mount on one side and a T-thread on the other. Since you do not need the camera lens when taking pictures through the telescope, you must remove it and thread the T-ring into the camera.

Now attach an adapter to the front thread of the T-ring, which has the same diameter as the eyepieces you are using on your telescope. For a DSLR, this should be a 2-inch adapter, as smaller tubes will not entirely illuminate the image sensor, and thus will create vignetting (i.e., dark image corners).

After this, you can mount the camera on the focuser of your telescope, replacing the eyepiece. The effective focal length equals the focal length of the telescope, as you will be imaging in the prime focus.

Mounting of a DSLR on the telescope.

1 *Camera with T-ring and 2-inch adapter.*
2 *T-ring and adapter mounted.*
3 *Camera with T-ring and adapter on the focuser of the telescope.*

Imaging Through the Telescope

1. Attach the remote controller to the camera
2. Set white balance to Daylight
3. Select the file format with the least compression (RAW, TIF, highest-quality JPG)
4. Activate internal noise reduction
5. Select ISO speed
6. Mount the camera with the T-adapter to the 2-inch focuser
7. Focus using the telescope's fine focus
8. If necessary, add a 2-inch extension tube
9. Set the exposure time
10. Use mirror lock-up
11. Take several exposures!
12. Check the tracking
13. Document your settings

If you are unable to get your object into focus due to the limited adjustment range of the focuser, you will need one or more extension tubes. It is a good idea to use a compact camera to document the precise setup of the extension tubes you used to focus your telescope properly. This allows you to recall the necessary information, if in the future, you happen to be in a similar situation.

Focusing

Since the autofocus of your camera does not work when you are doing prime focus photography, it does make sense to check the focus. Of course, you can check it on the built-in LCD monitor of the camera, and you can even enlarge the image by pressing buttons on the back of your camera. However, doing so requires that you touch the camera, which may inadvertantly change the focus on less rigid focusers. You will notice, indeed, that it is anything but easy to focus precisely by adjusting the fine focus of the focuser. For good astrophotos, however, the focus must be ideal.

The following two focusing aids will make it easier for you to find the right focus:

Your first option is to replace the rubber eyecup of the eyepiece with either an eyepiece magnifier or a right angle viewfinder with magnification, thus obtaining a magnified view of the focusing screen. A right angle viewfinder also provides a view that may be rotated by 90 degrees, which is easier on the neck when the camera is pointed straight up. Currently, the only Canon model that offers a live focus feature using its LCD monitor is the special astrophotography model, Canon EOS 20Da.

The second option is to use focusing software, but this requires a computer (or a laptop) at the imaging location. Using the software that is supplied with your camera, you can take pictures at short intervals and review these in higher magnification on your computer's monitor. You can reliably determine the most accurate focus setting in this way, but it is rather time consuming.

Activating the noise reduction feature on a Canon EOS DSLR.

Dark image with and without internal noise reduction (contrast strongly intensified).

It is by far more convenient to use the specifically designed software "DSLR Focus", which can be purchased for approximately $45 (see page 141). While continuously releasing the camera's shutter, this software analyzes the image of a selected object and uses digital data to specify the exact focus quality. The astronomical imaging software MaxIm DL offers a plug-in for DSLRs that serves the same purpose.

White Balance, Mirror Lock-Up, and Noise Reduction

For astro images, it is preferable to switch off the automatic white balance, and to select a manual setting instead (Daylight). It is also a good idea to use the mirror lock-up setting. This will cause the first press of the shutter button to flip up the mirror, and only the second press–occurring after the vibrations have died down–will open the shutter and expose the image. If your image is blurred even though the mirror was locked-up, this blurring is most likely caused by the movement of the shutter itself. You can remedy this by covering the opening of your telescope with black cardboard, starting the exposure, and then carefully removing the cardboard again. Repeat the same procedure at the end of the exposure.

Many camera models offer the option to activate internal noise reduction in their menus. This causes the camera to automatically take a dark exposure after long exposures (the shutter remains closed during these exposures). The camera then subtracts this dark image from your actual exposure. This process reduces the thermal noise of long-exposed images, but it also doubles the time needed to take your pictures, because the dark images require the same exposure time as your actual images.

Selection of the ISO Speed

When selecting the ISO speed, you need to find a compromise between low noise (i.e., low ISO of 50 to 100) and short exposure time (i.e., high ISO of 1600). I recommend starting with an ISO of 400 or 800.

The Pleiades. A cross, made from sticky tape, was used to create the spikes. Attach the tape across the lens shade, never touching the lens!

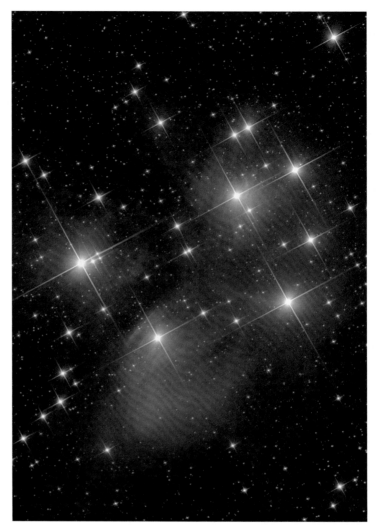

Selection of the Exposure Time

It is difficult to give specific recommendations regarding the exposure time, as so many factors are involved. In general, you can consider longer exposure times if the following factors apply:

▶ You are in a location with a dark sky
▶ You want to image a faint object
▶ Your tracking allows longer exposures without the stars trailing
▶ The ambient temperature is low, reducing the thermal noise of the camera

If the basic conditions are less than optimal, it is better to select a shorter exposure time and take more images instead. You can later create a master image on the computer, by stacking these single frames. Check your images

as you are shooting, as well as the respective histogram, which shows the distribution of brightness values in a picture (see pages 26-27). This will help you to find the ideal exposure time through trial and error.

Guiding

For longer exposures it is important that your telescope follow the movement of the stars precisely and consistently.

Since hardly any mount can accomplish this perfectly, you need to check the tracking during the exposure and make corrections if necessary.

The easiest approach to this is to mount a second telescope (guide scope) onto the main telescope, center a star in it, and monitor it through an illuminated reticle eyepiece. Any divergence of the star is instantly visible and can be corrected using the hand controller of the mount. However, in the long run, this method is tedious and annoying. Therefore, it is worthwhile to consider purchasing an autoguider, which automatically performs this monotonous task.

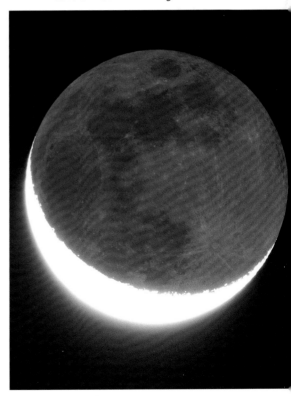

Earthshine of the waning crescent Moon.

Tips for the First Photos

Suitable subjects for your first trial are the Moon and the Sun (Warning: Only take images of the Sun with an appropriate solar filter in front of the telescope lens).

Set the white balance to Daylight for these motifs and select aperture priority from the camera's automatic exposure modes.

If the Moon or Sun does not fill the entire field of view, overexposures can occur. If that is the case, you can switch to spot metering or manually override the automatic shutter time by decreasing the exposure compensation by one to two stops to −1 to −2.

Check the focus of your pictures on the camera monitor using the highest magnification available. Take many exposures with different focus settings to determine the best point of focus.

As a next step, you can try large and bright subjects, such as the Orion Nebula (M 42), the Pleiades (M 45) in the constellation Taurus, the Andromeda Galaxy (M 31), the Beehive Cluster (M 44, also known as Praesepe) in Cancer, or if good viewing conditions up to the horizon allow it, the Wild Duck Cluster (M 11) in the constellation Scutum. Try to avoid nebulous areas that emit mainly red light, i.e., hydrogen-alpha areas such as the North America Nebula, because DSLRs do not record this light very well.

Tips and Tricks

The best file format: Always take your astrophotos with the highest image quality (usually referred to as RAW).

Time spent on focusing is time well spent: Always focus with the utmost diligence. Repeatedly focus past the actual point of focus, until the image gets out of focus again. Always take more than one image of an object. Do check the focus from time to time during a long exposure series.

Saturated pixels: Try to avoid large, overexposed areas (see page 26), although this may not always be possible when your image includes bright stars. Check the amount and distribution of saturated pixels on the histogram preview on your camera's monitor. If necessary, take a mixture of shorter and longer exposures that can later be combined on your computer.

Dirt particles on the sensor: Do not leave your camera body open, i.e., without a lens or body cap, for any extended period of time. It is important that you protect the sensor from dust and dirt particles that will appear as dark circles or lines in your images. If the sensor needs cleaning, do it very carefully, strictly adhering to the instructions of the camera's user guide.

Sun warning: Never aim your camera at the Sun with a flipped up mirror or with a lens and an open shutter! However, a landscape shot that includes the Sun is no problem.

High thermal noise: If, for no obvious reason, the thermal noise increases steadily during an exposure session, it is a good idea to take a break so that the camera's electronics can cool down.

Switch off image stabilization: If you are taking long exposures of the night sky with camera lenses, the autofocus function should be switched off. Any existing image stabilization feature, which prevents camera shake for normal daytime photography, should also be switched off!

Switch off in-camera image processing: Some camera models offer the option to adjust sharpness, color saturation, etc. in the camera directly after the exposure. Switch this feature off or set it to the lowest possible value.

Do not forget the memory card: If possible, adjust your camera settings in such a way that it will not expose without an inserted memory card.

Lens hood: Do take advantage of using your lens hoods (see page 75, bottom-right), as they block stray light from entering the lens, and protect the lens from dew formation in damp conditions.

Processing Your DSLR Images

Your first attempt at astroimaging may have been of the Moon, or you tried your hand at a bulb exposure of a nebula. As you can see in this chapter, these two types of images require radically different image processing steps.

Photos of the Sun and Moon

If you have imaged craters of the Moon through your telescope, you probably shot many pictures in order to compensate for focus errors and atmospheric turbulences (seeing). Although this strategy is quite useful, you should limit the number of exposures to a manageable size, because the first and most important image-processing step is to select the best and sharpest single frame from this series.

The individual processing steps are explained below with sample images of the lunar regions around the craters Clavius and Tycho (Image 1). For further comprehension and practice you can download these images from http://www.astromeeting.de/astrophotography_digital.htm. The specified procedure is not only applicable to images of the Moon, but is also suitable for images of the Sun as well.

Select the Sharpest Image

If you attempt to open all images of an image series at once from your image processing software (e.g., Photoshop), this will almost certainly overload the computer's memory. Therefore, start by opening only the first five images in your series. While comparing these images, make sure that you evaluate the sharpness using the 100% view. If your image cannot be displayed fully on the monitor, use the horizontal and vertical scroll bars to review all parts of the image. Do not restrict your quality check to just a small area of the image (e.g., a lunar crater or sunspot), but always review the entire image, as atmospheric seeing can lead to images with narrow parts that are very sharp, while the rest of the image is out of focus.

If the difference in sharpness quality of two images is not apparent, you can place the respective image viewing windows side-by-side, providing you with a direct comparison. Of the five open images, select the one you consider to be the best and close the remaining four images. Now, open the next five images and compare each one with your "favorite"; then keep the best and close the rest. Repeat this procedure until you have reviewed each image in your image series.

1 Lunar craters Clavius and Tycho.

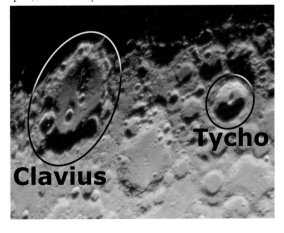

Try this practice exercise by selecting the best of five images found on my website at http://www.astromeeting.de/astrophotography_digital.htm. The goal here is to select the best image from the five sample images DSLR_1. tif up to DSLR_5.tif. First, arrange these five images next to each other to allow a direct comparison, and zoom in at 100%.

If you look at the crater Clavius in the file DSLR_2.tif (top center) and compare it to DSLR_5.tif (right) you can readily see that both can be omitted due to blurring. DSLR_3.tif and DSLR_4.tif (bottom left and center) seem to be identical with regard to the sharpness of Clavius, so this decision is more difficult. But, if you scroll to the right in both images, and compare the sharpness of the crater Tycho, the decision is clearly in favor of image DSLR_3.tif (left image):

Thus, DSLR_3.tif wins, and you can close all other windows

Averaging, by the way, is not really useful for images of the Sun and Moon. Due to the brightness of both objects, single frames (if exposed correctly) already exhibit a rather good signal-to-noise ratio. Furthermore, several images cannot be precisely layered due to atmospheric turbulences, which may cause distortions in different image areas.

Exposure Check

The brightness range of an image should be used to its full capacity without causing an overexposure. Keep an eye on how closely the values of the histogram approach the right edge. This is the characteristic histogram of a correctly exposed Moon image:

An underexposure fails to utilize the full dynamic range of the image (see dialog box top left, right end of the histogram), thus causing image noise.

In an overexposed image, many pixels are already completely saturated (the brightness values reach the right edge, see dialog box top right).

Thus, the strategy is to select a correctly exposed single frame that was shot during excellent seeing and with the ideal focus from the series of images.

In order to accomplish this, you need to check the histogram of the Moon image DSLR_3.tif, and look at each color channel separately (red, green, and blue). For this purpose select the menu item Image>Adjustments>Levels in Photoshop. A dialog box appears which allows you to select each color individually, for example green (at right):

The far ends of black and white sliders (below the value area) are the absolute black and absolute white points, respectively. Now, move the

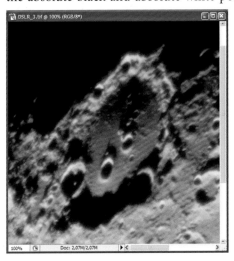

black slider to the right until it reaches the first sharp increase in values. Move the white slider to the left until it reaches the point where the values have fallen off.

Repeat this procedure for the red and blue channels, as well. The final result is an image with natural looking colors and a balanced ratio of brightness values from white to black.

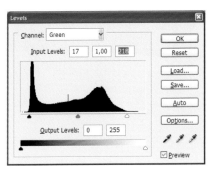

Sharpen the Image

In the next step, you can try to improve the image sharpness by using the Photoshop menu item Filter>Sharpen>Unsharp Mask... (see dialog box below). Apply this filter cautiously and do not overdo it! You may sometimes achieve the best results if you apply this filter repeatedly with a slightly lesser effect each time. Images that receive too much sharpening appear unnatural, show an increase in noise, and sometimes even exhibit artifacts, i.e., structures that are not real.

This is clearly visible in the following comparison: The image on the left shows the unsharpened RAW image, the image in the center shows a moderately sharpened image, and on the right is shown an overly-sharpened image.

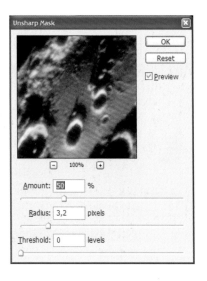

The image in the center was sharpened using the menu item Filter>Sharpen>Unsharp Mask... with the settings shown in the screenshot at left.

Brightness, Resizing, and Resharpening

The overall impression of the image is still rather bright. If you agree, select the menu option Image>Adjustments>Curves, and make the necessary adjustments here.

Now the image processing is almost done.

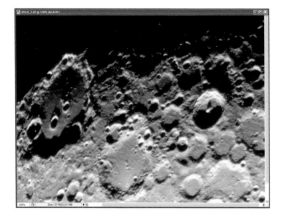

Due to the color interpolation of DSLRs, the nominal resolution of the image sensor cannot be used completely. Therefore, many images will appear sharper if they are reduced in size by a third. In this process, no image details are lost. In Photoshop, select the menu item Image>Image size, which will open the respective dialog box. Enter 66% for the desired width and height.

Depending upon the result, you may choose to apply an additional resharpening, following the procedure described on the previous page. The final result should resemble Image 2, shown at right.

Photos of Deep-Sky Objects

For bulb exposures of faint, night sky objects (star clusters, galaxies, and nebulae) additional processing steps are necessary, which are quite different from those used for images from a CCD camera. In order to reproduce the processing steps outlined below, you can download the sample images DSLR1.tif up to DSLR4.tif from http://www.astromeeting.de/astrophotography_digital.htm.

These files contain images of the Veil Nebula in Cygnus that were exposed for ten minutes at ISO 800.

Check Image Noise

Open all four files simultaneously in Photoshop. The DSLR camera that was used to shoot these images (Canon 20D) produces such low-noise images that no dark frames were required. Even the in-camera noise reduction was not necessary. However, if you do notice high noise in your images, use the noise reduction feature of your camera. If your camera

2 Finished image of the lunar crater

does not offer this feature, you need to take separate dark frames, which will then be subtracted from the individual color frames (see page 79 for further explanation). The imaging processing software ImagesPlus, MaxIm DL/CCD, and MaxDSLR are well suited to this procedure (see also page 141).

Conversion to 16-Bit Mode and Removal of Hot Pixels

First of all, the images should be converted to the 16-bit format, thus allowing Photoshop to better calculate averaging. You can accomplish this by selecting Image>Mode>16-Bit>Channel. Repeat this procedure, which will not visibly change the images, for all four pictures.

To remove the bright spots (hot pixels) without subtracting dark frames, select the menu item Filter>Noise>Dust&Scratches... with the following parameters (see dialog box on the right).

By selecting and deselecting the option *Preview* you can see the effect of this feature.

Averaging the Image

The next task is to stack the images precisely. A suitable approach to this is to average two pairs of images, then to average the respective results again: The more images that are averaged, the more the noise decreases.

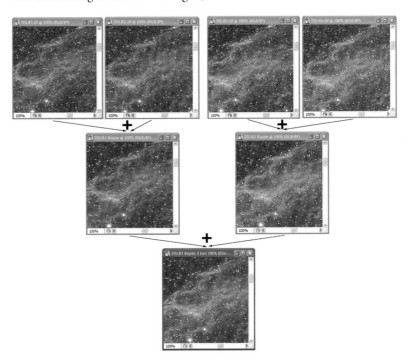

This is the step-by-step procedure in Photoshop: First, average images DSLR1.tif and DSLR2.tif. To do this, you will select the file DSLR2.tif and click on *Select/All*. Then copy the image to the clipboard using *Edit/Copy*. Next, click on the image DSLR1.tif and paste the image from the clipboard with *Edit/Paste*. Photoshop adds the second image in a separate layer.

> **Tip**
>
> You can find out how to remove a satellite trail from your image at http://www.astromeeting.de/astrophotography_digital.htm.

If necessary, display the Layers Palette by selecting menu item Window>Layers, or by pressing F7 .

To stack the layers precisely, click on the top layer and change the blending mode from *Normal* to *Difference*.

Do not be alarmed if your image looks somewhat strange (see figure at right). Zoom to 100% and select the *Move Tool* in Photoshop.

Using the mouse cursor or the arrow keys, you can now move the top layer against the layer underneath, and thus instantly spot any divergences from a precise stack. The image on the left is not stacked well, whereas the image on the right shows an ideal stack.

If the images are congruent, switch the blending mode back to *Normal* and change the opacity to 50% (see next page). Now, the two layers can be merged by selecting the menu option Layer>Flatten Image.

In this way, you have created the average from the files DSLR1.tif and DSLR2.tif, and have thus reduced the noise.

This is your first average image.

Now, apply the same procedure to the image files DSLR3.tif and DSLR4.tif. This will result in the second average image. To obtain an average of all four images, you now average the two averaged images following the same procedure. When you have created your final average image it is a good idea to save it under a meaningful name.

Adjust the Histogram

To use the brightness range of the image to full capacity, you now adjust the histogram for the red, green, and blue channels, respectively. Here you can follow the processing steps that were outlined earlier for the lunar crater image (see page 86). The screenshot at left shows the adjustment for the red channel.

Tip

If you have an uneven number of exposures, you can also stack three layers. Set the opacity for the middle layer to 50%, and set opacity for the top layer to 33%.

Size, Brightness, and Resharpening

What applies to Moon images taken with a DSLR, is also true here with images of deep-sky objects: The image sharpness is improved when you reduce the file size by one third (to 66%). Depending upon your own taste, you can choose to resharpen slightly, increase the color saturation using menu item Image>Adjustments>Hue>Saturation... (Increase saturation to +22%), and change the curves as outlined on page 132.

You can also crop a few pixels from the outer edges that might have been slightly distorted by the moving and stacking actions. For this purpose, select an appropriate area with the Rectangular Marquee Tool and click on menu option Image>Crop. Afterwards, you convert the image to the 8-bit mode again, by selecting Image>Mode>8-Bit>Channel.

The final result (Image **1** on the top of this page and on pages 60-61) displays a neutral sky background, vivid colors as well as a nicer coloring of the brighter stars.

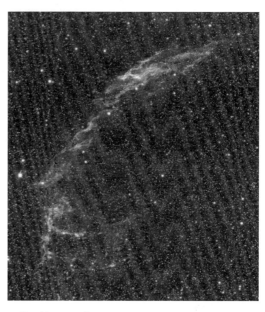

1 *Final image after processing*

The Witch Head Nebula (NGC 1909) in the constellation Orion. To obtain this result, eight ten-minute exposures were averaged.

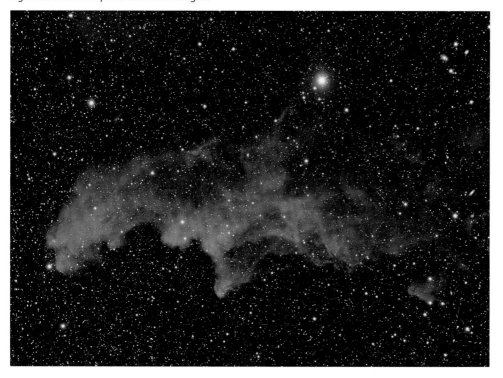

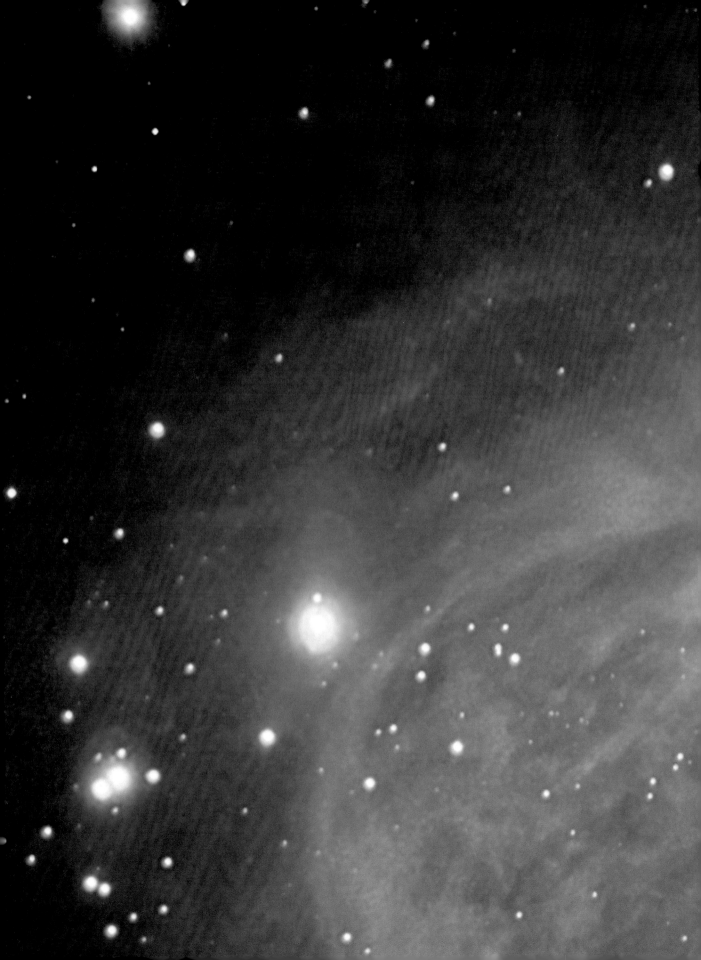

Chapter 5
The Astronomical CCD Camera

Application Areas of an Astronomical CCD Camera

An astronomical CCD camera can be considered the Rolls Royce of astrophotography cameras. In particular, with regard to deep-sky images, its results are unmatched. Its handling, however, is complex and it comes with a very high price tag.

Characteristics of a CCD Camera

Astronomical CCD cameras are designed specifically for astrophotography. Therefore, they produce excellent images in this area, but cannot be used for other purposes. Their image sensor is actively cooled in order to reduce the thermal noise. Inherently, most astronomical CCD cameras only provide monochrome images and they can only be operated in conjunction with a PC or laptop.

Unfortunately, the handling of a CCD camera is not as straightforward as that of a digital camera for everyday use. Camera models with a

Deep-sky objects such as the nebula surrounding Gamma Cygni in the constellation Cygnus are ideal subjects for an astronomical CCD camera.

large sensor and/or many pixels are also quite expensive. Even for an entry-level model you will need to pay close to $700, the medium range models cost many times that, and for the high-end models the sky's the limit. Yet, if you are willing to put-up with the costs and the rather complex handling, you are rewarded with outstanding image quality.

Star clusters are also well-suited photo motifs for CCD cameras. Here, the double cluster "h and chi Persei" in the constellation Perseus.

Suitable Photo Motifs

Due to its specific design, the astronomical CCD camera is uniquely suited for bulb exposures. If you do not mind the time and effort, you can also use it for bright subjects with short exposure times.

The astronomical CCD camera is suitable for a vast range of applications. It only reaches its limit if you want to take quick snapshots or image a colored motif that changes rapidly. This is due to the fact that most CCD

cameras require separate exposures through colored filters (red, green, and blue) in order to produce a color image.

Ideal target objects for a CCD camera are all those deep-sky objects that can be displayed on a useful image scale based on their respective size, the size of the image sensor, and the available focal lengths (see pages 10-11). These deep-sky objects include diffuse nebulae such as emission, reflection, and dark nebulae; galaxies, open clusters, globular clusters, and planetary nebulae; as well as supernova remnants.

Most camera models allow the precise definition of the magnitude and position of a celestial object through image analysis. If you are interested in measuring the magnitudes and positions of minor planets, comets, variable stars, or supernovae, an astronomical CCD camera is a suitable tool. Employed correctly, it even permits scientific studies.

The Veil Nebula region in the constellation Cygnus. You can compare the left part of the photo directly with an image taken with a DSLR on page 91.

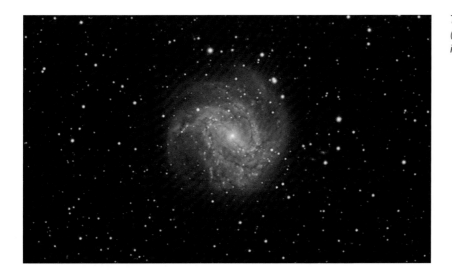

The spiral galaxy M 83 (also called Southern Pinwheel) in the constellation Hydra.

Advantages and Disadvantages of a CCD Camera

+ Low Thermal Noise

The sensor of a CCD camera is actively cooled to reduce the thermal noise, allowing most cameras to maintain sensor temperatures which are 25-35 degrees below the ambient temperature. The cooling of the sensor dramatically reduces the image noise caused by heat. If the sensor gets warm the signal-to-noise ratio increases, i.e., the image becomes grainier and the faintest details of a nebula, for example, will no longer be visible, because they are obscured by the noise. However, a reduction of the sensor temperature by only 7 degrees will halve the thermal noise! This means, if the sensor gets cooled by 14 degrees, only a quarter of the noise is left; and if its maximum cooling capacity is used, thus reducing the sensor temperature by 35 degrees, only one thirtieth of the noise is left.

+ High Resolution

A big plus of most astronomical CCD cameras is that they have a monochrome sensor instead of a color sensor. Granted, the production of color images with a monochrome camera is time-consuming, as separate exposures through red, green, and blue filters are required. These are later combined—with the help of software—to produce a color image.

However, the image resolution, and this means ultimately its sharpness, is far superior when compared to a one-shot color camera, where the individual pixels of the sensor are covered with an array of tiny color filters.

Typically, in a color sensor four pixels are provided with one red, one blue, and two green filters, respectively. If you take a picture of a

The globular cluster M 13 in Hercules.

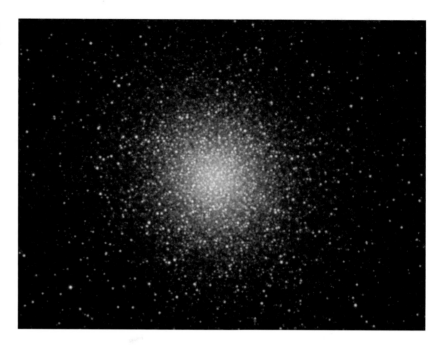

predominantly red motif with such a camera, only the pixel with the red filter will receive a signal. The other three pixels remain dark. Thus, the final image cannot provide the full theoretical resolution of the image sensor.

A monochrome camera works differently. All its pixels will record a brightness value for the single-colored red motif. The result is an image matching the resolution, as specified in the technical data sheets of the camera. The actual benefit from such a resolution, however, depends upon the optics used and the exposure conditions. Thus, a decision regarding a color sensor—either in favor of or against it—should be carefully considered.

+ Large Dynamic Range

The astronomical CCD camera has a clear advantage regarding bit depth. Bit depth quantifies how many brightness values per pixel are theoretically possible, i.e., how precisely the camera can differentiate brightness

16-bit photo (left) and 8-bit photo (right) after stretching of the histogram: With 8-bit there are perceptible "steps."

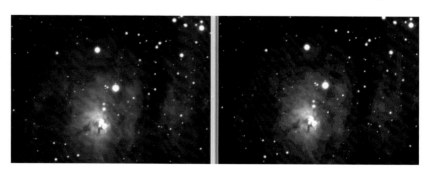

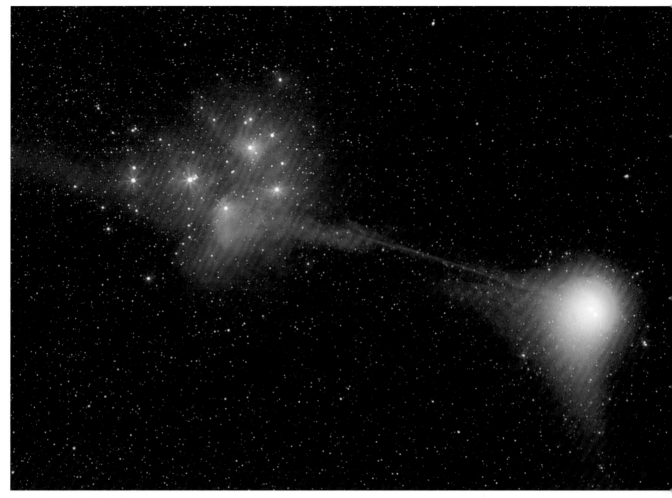

Comet Machholz (right part of the image) passed by the star cluster of the Pleiades in the constellation Taurus, at the beginning of January 2005. Imaged with a 300 mm camera lens.

levels and how large its dynamic range is. What does this imply in practice?

Let us first take a look at an astronomical CCD camera that uses a 16-bit A/D converter (A/D signifies Analog/Digital, as the CCD sensor outputs an analog signal). Each pixel has a bit depth of 16 and can thus display 2^{16} or 65,536 distinct brightness values per pixel. For a gas and dust nebula this means, for example, that the brightness range from the bright center to the faint edge details will be very smooth, without any distinct "steps." With such a camera it is possible to set an exposure time that records the bright core areas of a nebula without overexposing them (i.e., the structures are kept), and at the same time captures the faint outer areas. The bandwidth of brightness levels that can be displayed is called dynamic range.

Let's compare this with a DSLR. In JPEG mode the DSLR saves only 8-bits per pixel and color, which translates to 2^8, or 256 brightness levels per color. And, even in the RAW mode this camera reaches a maximum of 12-bits per pixel and color, translating to 2^{12}, or 4,096 brightness levels.

Employing a DSLR in practice means that, with respect to the above-mentioned nebula, you might have to decide between a short exposure time in order to avoid overexposing the bright core areas, and a longer exposure time, which may overexpose the core areas, but will capture the faint outer areas. To display both areas appropriately, the only solution is to combine images with different exposure times. If you try your hand at the following motifs, you will certainly appreciate the large dynamic range of an astronomical CCD camera: the Orion Nebula (M 42), the Andromeda Galaxy (M 31), or the globular cluster in Hercules (M 13). Other excellent motifs include the terminator region of the Moon, with its high contrasts, or the Sun in hydrogen-alpha light, when the bright disk of the Sun, as well as the rather faint prominences, shall be captured simultaneously.

+ True RAW Data

In general, all astro images require post-processing. For this, it is ideal to obtain the unadulterated image data, as it is supplied by the A/D converter after the readout of the sensor.

This is the case with an astronomical CCD camera: a true advantage compared to a DSLR, where the image data is automatically altered within the camera. The DSLR cameras provide files that have been processed by the camera's software even in the RAW format and when all sharpening features have been switched off. Astronomical CCD cameras are indeed different: Here you can process true RAW data, and can thus determine the intensity and effect of the sharpening during later image processing.

+ High Spectral Sensitivity

Another advantage of a true astronomical camera is the high sensitivity of its sensor, which often extends beyond the visible spectrum, including infrared and ultraviolet wavelengths. This allows you to observe in these specific wavelengths, or to utilize the additional wavelengths to obtain an improved signal for your images. Some celestial objects, for example, emit part of their light in the near infrared. When imaging such an object with an astronomical CCD camera without any filter, shorter exposures can be taken, because the camera also records the infrared light. However, this only works if the imaging optics let this light pass through and can bring it into focus together with the other wavelengths. Many refractors (as well as camera lenses) are not corrected for infrared light: In other words, they have a different focal point for infrared. This will cause blur-

ring in the monochrome astronomical CCD camera, but can be avoided by adding an infrared blocking filter. This is not a problem with reflecting optics, because they converge the light rays of all wavelengths at a common focal point. Pure reflecting telescopes are also better suited for ultraviolet images, because the glass elements used in refractors often absorb most of the UV light.

In general, the astronomical CCD camera's ability to capture a wider range of wavelengths is a great advantage, as undesirable wavelengths can easily be excluded by using appropriate filters. In contrast, DSLR cameras have a built-in filter in front of the sensor that cuts off extreme wavelengths. While this is an advantage for normal daylight photography, it is not optimal for astrophotography.

+ Extensive (Guiding) Accessories

Another big plus of astronomical CCD cameras is the broad range of available accessories. Specially designed for astrophotography, manufacturers offer color filter wheels, filters, spectrographs, separate autoguider heads, additional cooling systems, and even adaptive optics modules to compensate for seeing effects.

But first, we will take a look at how to compensate for tracking irregularities of the mount during bulb exposures.

This tracking control is called guiding, and is necessary for every mount given longer exposure times.

For this fuction, many of the astronomical CCD cameras of the manufacturer SBIG (Santa Barbara Instrument Group) include a second image sensor built into the camera. During the exposure of the main sensor that images the actual subject, the second sensor is used to automatically and continually monitor in short intervals. The camera control software analyzes the image of the guide sensor, and immediately recognizes when the guide star shown on it moves slightly. This is done with utmost precision so that the software can correct the mount through its control commands, before the divergences become visible in the actual photo.

The manufacturer Starlight XPress opts for a different method, and offers models for which a separate guiding head is available. This separate guiding head is equipped with a separate CCD sensor and is either attached to a guide scope or to an off-axis guider. Starlight XPress also offers cameras, where only half of the CCD sensor is read-out in short intervals during the exposure. This information is then used for guiding by the camera software. Although 50% of the sensor's light sensitivity is lost through this method, it does allow you to guide on the actual object you are imag-

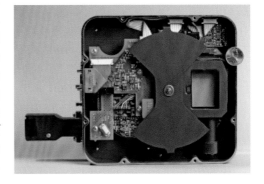

An SBIG-STL camera with a large sensor, the small guiding sensor is on the left.

SBIG-ST-10 on C14 telescope with off-axis guider and ST-4 autoguider (top left).

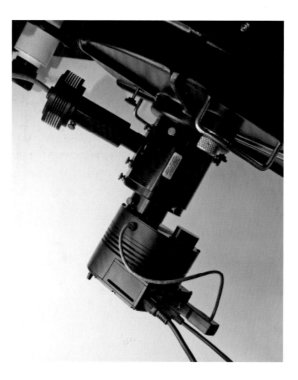

ing. This is a useful feature if you are imaging objects that move independently from the stars, such as asteroids and comets.

SBIG offers separate guiding heads as optional accessories.

+ Camera Shake Avoided

Astronomical CCD cameras are entirely controlled via software. There are no control elements on the camera itself. This is a great advantage, as there is no need to touch the camera during or between exposures, thus avoiding the risk of camera shake with potential effects on the field-of-view or loss of sharpness.

+ Camera Lens Adapter Available

Astronomical CCD cameras are not equipped with lenses.

These specific cameras are primarily intended for the use with a telescope, where the telescope lens or mirror then creates the image on the CCD sensor. If you would like to use wider angles in order to image large celestial bodies, camera lenses can also be adapted. However, corresponding adapters may not always be available retail, in which case, you need to build something yourself, or have it custom built. If you already own a few camera lenses, this adaptation provides a real added value, because each new focal length opens up the possibility to capture a multitude of different objects. Extreme wide-angle lenses or fisheye lenses are very useful for

imaging large sky areas: be it to photograph structures and dark nebulae of the Milky Way, or to scan a rather large area in search of meteors.

– No Viewfinder

The biggest disadvantage of an astronomical CCD camera is that it comes without a viewfinder. Only a test exposure on the computer screen will show what field-of-view is captured. And, when changing the field-of-view, it will take some time and experience before you are able to move the telescope and the camera correctly at first go. The same applies to focusing.

– Computer Required

The dependency upon a computer is also a disadvantage, especially if you travel to remote locations with dark skies, where no power supply is readily available. If you don't already have a laptop computer, you need to invest in one. It is no problem to run the mount and the CCD camera on 12-volt batteries for a night, however, the batteries of a laptop (and this includes the energy-saving models) will not last an entire night. You can, indeed, find 12-volt adapters for laptops as well, but laptops still require a lot of power. Better suited for your purposes are laptops that provide a slot for a second, optional battery.

The Astronomical CCD Camera

+ Advantages	– Disadvantages
Relatively low noise through sensor cooling	Complex handling
Large dynamic range	Computer required
High resolution with monochrome sensor	Time-consuming color shots
True RAW data	Use limited to astrophotography
High spectral sensitivity, shorter exposure times	Difficult to set and focus
Good guiding capabilities	High purchase price
No camera shake; hands-off operation	Short exposure times not possible with all cameras
Camera lenses can be adapted	
Large range of applications; maximum image quality	

In the energy-saving mode (e.g., by switching off the display during exposures), the batteries will last an entire night without recharging. However, do not take your energy saving measures too far. You do not want the laptop to automatically switch to stand-by mode during exposures, since this can interrupt the connection to the camera and the image may be lost.

– Complex and Cumbersome Handling

Compared to a DSLR, astronomical CCD cameras are quite complex and cumbersome in their handling. They are also exclusively designed for astrophotography; Normal daylight shots for documentation or souvenirs are not possible. As mentioned before, the creation of color images is also rather time-consuming.

– High Purchase Price

Another disadvantage of the astronomical CCD camera is the high price: Since they are only produced in small quantities, they are quite expensive. Moreover, the software that is supplied with the current models is rather basic. Additional software to control the camera and the guiding, as well as to process the images, will make the life of an astrophotographer much easier (see page 106).

– Short Exposure Times Not Always Possible

Some astronomical CCD camera models do not have a mechanical shutter. This is irrelevant for bulb exposures, but it is relevant when it comes to short exposures of bright objects such as the Sun and the Moon. Without a shutter, the sensor continues to collect light, while the image sensor is read by the electronics. The result is a bright trace that extends from the object into the read-out direction. Only when the read-out time is insignificant in relation to the exposure time can you neglect this disadvantage. Thus, if you want to use your astronomical CCD camera for Sun and Moon shots, select a model with a mechanical shutter that covers the sensor during the read-out time.

You can find a direct comparison of the areas of application of the different camera types in the Appendix.

Bright read-out trace on short exposure without a mechanical shutter.

Buying Tips for CCD Cameras and Accessories

Those who invest in a dedicated astronomical CCD camera are totally committed to astrophotography. The purchase of such a camera involves great expenditures and should be carefully considered.

Tips for the Purchase of the Camera

The leading manufacturers of CCD cameras are the companies SBIG and Starlight XPress (see page 143). Important criteria for the selection of a camera are, for example: pixel size and the size of the image sensor, light sensitivity, dynamic range, sensor cooling, availability of a guider, read-out speed, a broad range of available accessories, as well as availability of technical support. You can find a detailed list of selection criteria at http://www.astromeeting.de/astrophotography_digital.htm.

Suggested Accessories

Connectors, Tubes, and Filters

After the purchase of a CCD camera, you should check if the correct cables for the respective ports have been supplied, and if the camera driver and software can be installed on your computer or laptop without any problems.

You need to pay particular attention to the autoguider connector on the mount, or rather telescope drive, since there are different connectors and cable assignment standards for guiders. Potentially, you might need a different cable or an adapter. It is also important that the CCD camera be supplied with the corresponding nosepiece for your focuser, in case you use a 1.25" focuser. If the camera's nosepiece is 1.25" and your focuser is 2", you will need a 2" to 1.25" reducer.

Different CCD camera models, from left to right: SBIG ST-10 with attached filter wheel, SXV-H9 from Starlight XPress, and an SBIG STL-11000.

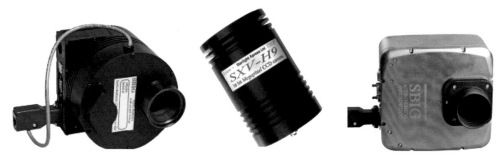

Filter wheel of a SBIG STL camera containing a red, green, blue, H-alpha, and clear filter.

With a monochrome CCD camera, you will get black and white images. In order to take color images, you need an additional color filter wheel with a matching set of red, green, and blue filters. It may sound like pure luxury to have a motor-driven filter wheel, but it is indeed beneficial if you do not have to touch the camera for a filter change. Because not all mounts and focusers are totally rigid, you could unintentionally alter your field-of-view, or lose your guide star while manually changing a filter. Moreover, it is rather difficult to combine the single frames to a color image if they are not identical. Therefore, it is extremely helpful to have a motor-driven filter wheel that is controlled by the software.

If you are working with a refractor and do notice image blurring through infrared or ultraviolet light, an additional investment in a UV/IR blocking filter is worthwhile.

Practical Software

If you prefer to work comfortably from the start, without having to battle with the rather minimalist feature set, and at times, the unsubtle programming of the camera's original control software, the purchase of AstroArt or MaxIm DL CCD software is recommended (see also page 141).

Both programs make it much easier to focus, guide, and evaluate the raw data, and to control automatic exposure sessions. Image calibration of the RAW images is also much easier with this software.

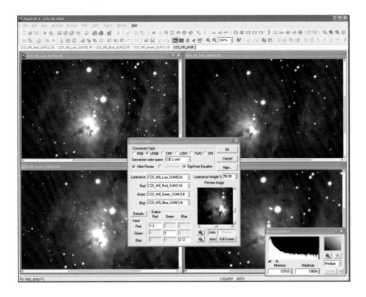

Software such as MaxIm DL greatly facilitates working with a CCD camera.

Focal Reducer

If you do not have any experience yet regarding long-exposed astrophotos, you should definitely start with shorter focal lengths. Focal lengths up to 500 mm (and 1000 mm at most) are ideal. If your telescope has a longer focal length, you should consider buying a focal reducer (Shapley lens, see box on page 108). It will also serve you well later, because it provides a larger field-of-view and a faster focal ratio, i.e., you get by with shorter exposure times. In particular, your guiding will profit from it, as the required guiding accuracy is lower with a shorter focal length. To precisely guide telescopes with a focal length of two to three meters is a challenge even for a seasoned astrophotographer.

Field Flattener, Coma Corrector

Large sensors are problematic if your telescope has a curved plane of focus, rather than one that is perfectly flat. While this does not matter for visual observations, it is crucial for astrophotography. Telescopes of the Schmidt-Cassegrain design suffer from field curvature, as do expensive refractors.

Image distortion through coma: Stars at the edge are elongated.

Example for Reducing the Focal Length

Let us use a Celestron 8" or Meade 8" Schmidt-Cassegrain telescope as an example. These usually have a focal length of 2000 mm and a focal ratio of 1:10. This focal length is too long for a beginner. However, reducers are available that decrease the focal length by the factor 0.63 to 1260 mm (with a focal ratio of 1:6.3) or by the factor 0.33 to 660 mm (with a focal ratio of 1:3.3). With such a reducer the image scale is decreased accordingly, the field-of-view is enlarged, and the required exposure time is shortened by the square of the reducing factor. For example, if you need to expose for ten minutes at 1:10, a minute will be sufficient when you employ the 0.33 reducer. It gets more difficult though, if you are using a CCD camera with a large sensor. In this case, if you apply a 0.33 reducer, the image sensor might not get illuminated completely, resulting in dark image corners. In this case, you should revert to the 0.63 focal reducer.

Whereas the resulting defocused corners might still be acceptable on a smaller sensor, this is not the case with a larger sensor. Thus, if your camera has a large sensor, you should check if a respective field flattener is available for your telescope. These field flatteners are not interchangeable, i.e., they can only be used with a specific telescope type. Before investing in this accessory, you should first see what kind of results you achieve without it.

Telescopes of the Newton design suffer from a different shortcoming, namely the increasing coma off the image center. This can be remedied by a coma corrector, which can be employed to a certain extent on various Newton telescopes.

12-Volt Adapter for Use in the Field

If you want to power your camera in the field with a battery or with a car's power supply, you need to purchase an appropriate 12-volt adapter.

Budget

The table at right provides sample calculations for CCD cameras plus accessories. The prices are reference values (June 2007).

The calculation excludes the following items, assuming that they are already available: a telescope on an equatorial mount offering the capability to make fine adjustments, and a computer with sufficient disk space for the image data as well as backup capabilities.

Sample 1 (entry level)			Sample 2 (mid-range)		
Camera Starlight XPress MX5 500 × 290 pixels (= 145,000 pixels) Sensor size 4.9 × 3.6 mm Pixel size 9.8 × 12.6 μm 12-Bit (4096 gray levels)	$	985.00	*Camera* SBIG ST-2000XM 1600 × 1200 pixels Sensor size 11.8 × 8.9 mm Pixel size 7.4 × 7.4 μm 16-Bit (65,536 gray levels)	$	3395.00
Software Astroart	$	185.00	*Color filter wheel* SBIG CFW-8A with RGBC filters	$	895.00
			Software MaxIM DL	$	449.00
Total	$	1170.00	Total	$	4739.00

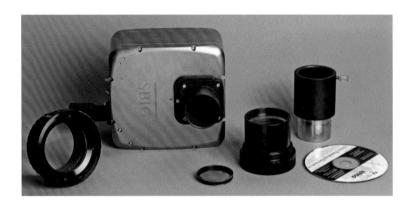

From left to right: Field flattener, CCD camera, blocking filter, Shapley lens, extension tube, software.

Taking Astrophotos with a CCD Camera

An astronomical CCD camera is used mainly for taking pictures through the telescope. However, you can also attach a camera lens to the CCD camera for wide field imaging.

Photography with a Camera Lens

It is not difficult to attach a camera lens to a CCD camera, if the corresponding adapter is available retail. If not, the only solution is to build the adapter yourself. Thereby, you need to ensure that the lens can be focused to infinity: The distance from the rear lens mount to the sensor plane must not exceed the so-called flange focal distance of your camera. How large the flange focal distance is for a particular camera, depends upon the manufacturer. You can find an overview of different lens mounts and their respective flange focal distances at http://en.wikipedia.org/wiki/List_of_lens_mounts.

If you build it yourself, I would recommend falling a tiny bit below the flange focal distance. Thus, you ensure that you actually reach the infinity focus and do not have to stop short off the ideal focus, because the stopper of the distance scale does not allow further movement. Mounted on a telescope, you can thus take long exposures of constellations or the Milky Way.

Photography Through the Telescope

Preparation of an Exposure

Since an astronomical CCD camera does not have a viewfinder, you should carefully plan your exposures. Determine beforehand at what focal length you want to image each object. This helps you to avoid unpleasant surprises; e.g., the selected object does not fit on the image or appears infinitesimally small on the image field.

For a start, select a subject that is not located too close to the horizon and which has not yet culminated. In this way, you have enough time to take the necessary number of images, before the object sets. Also, begin with a bright object that is clearly visible in the eyepiece (see pages 114-115). Allow for some buffer time to cover potential delays through unexpected difficulties.

Attachment to a Telescope

First, connect the astronomical CCD camera to the computer, run the control software, and activate the cooling of the sensor, which will take a while. In the meantime, aim the telescope at a bright star (at least second magnitude), which is close to your desired object, then focus the image with an eyepiece, and center the star in the field-of-view.

Attachment of a camera lens to a CCD camera.
1 Self-made adapter. *2 With mounted lens.* *3 Piggyback on a telescope.*

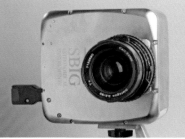

Astrophotos Through the Telescope with the CCD Camera

1. Determine object and exposure focal length

2. Connect the camera to the computer, run the software, and activate sensor cooling

3. Aim the telescope at a brighter star that is near your object, then center it in the field-of-view using an eyepiece with medium magnification

4. Connect the CCD camera to the telescope

5. Take a test exposure–is the star visible?

6. Focus with continuous shooting in 3 x 3 binning mode; if necessary, use an extension tube

7. Aim at the exposure object

8. Take a test exposure–is the object visible? If necessary, turn the camera to better position the object

9. If needed, select filter; refocus if necessary

10. Fine focus on a star in the same field-of-view as your object (1 x 1 binning)

11. Select the exposure time

12. Start exposure!

13. Check guiding

14. Save images using meaningful file names

15. Take multiple single frames (recommended: nine exposures for the luminance channel, three exposures for each color channel), average them later

16. Take dark frames with the same exposure time, same binning mode, and identical sensor temperature

17. Take flat field frames with the same camera position, focus, binning mode, and filters (switch off the tracking for flat field frames of the sky at dusk or dawn)

Attaching the astronomical CCD camera to the telescope is very straight-forward: The camera's nosepiece (either 1.25" or 2") is plugged into the focuser of the telescope, i.e., the camera replaces the eyepiece. With this, you are working in prime-focus, which means your telescope acts like a lens with a very long focal length. If you now take a test exposure of one second (without a filter), a circle (or ring when you are using a reflector) should be noticeable on the monitor. If nothing is visible, try to adjust the histogram display. If still nothing shows up, center the star again, this time employing an eyepiece with a short focal length or a reticle eyepiece.

Focus – Part I

The large, bright circle on the exposure of the CCD camera is the unfo-cused image of a star. If the software of your camera provides continuous shooting, use it to shoot one image after the next, while it is displayed on

 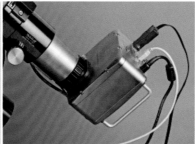 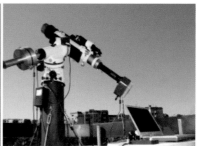

Mounting a CCD camera on the telescope.
1 *CCD camera.* **2** *Plugged into the focuser.* **3** *Ready-to-operate on the telescope.*

the monitor. While the camera works in this mode, you can try to find the best possible focus by adjusting the focus knob of your telescope.

The size of the circle decreases until it becomes a tiny bright spot. At this point, a rough focus is sufficient, since you might still need to remove the camera or adjust its position in the focuser. If you use the 2 x 2 or 3 x 3 binning mode for the rough focus, the read-out of the images from the camera is much faster and the latest results are shown in shorter intervals. If you do not reach a focus point, you might have to add an extension tube. Try to do without diagonals (prism or mirror), because this adds unnecessary optical components to the optical path. If you are employing diagonals anyhow, remember to flip the image horizontally later, because it will be inverted.

Acquisition of the Target Object

If you have found the true point of focus, in addition to the bright star, faint stars will become visible as well. This gives you an idea of how sensitive to light such a camera is, and how much it captures in a one-second exposure.

Now, aim your telescope at your target object. You may need to remove the camera for this and replace it with the eyepiece, to ensure that the object is still centered on the image. In doing this, do not alter the focus point on the focuser, but rather, slide the eyepiece out of the focuser draw tube until you have a focused view. You can "memorize" or mark this position: In this way you obtain an eyepiece that is parfocal to your camera, which makes it much easier in the future to find the right focus at first go (see page 46). If you now take another one-second test exposure, your target object will be distinctly visible on the monitor–a truly intriguing moment time and again. Position it at the image center by moving the mount slowly with its motor drive, and extend the exposure time to 10 seconds.

Setting the 2 × 2 binning mode in the software MaxIm DL.

First view of the photo motif on the monitor.

Now, even faint areas of the motif become visible, and you can determine how and where you would like to position it on the image. For elongated objects, such as a galaxy, you may prefer to turn the camera to achieve a better image composition. However, do this carefully to avoid any unintentional shifting of the mount. Ensure that all clamp screws of the mount are securely tightened.

Focus – Part II

If you are pleased with the result so far, the focus needs to be optimized once more. For this purpose, aim at a fainter star that is close to the center of the image, and expose it for a short time, so that the star is not overexposed, i.e., the brightest pixels of the star are not totally saturated. With some of the camera control programs, you can then mark a small square in the frame, which shows the selected star at its center. Now, only this marked area of the image sensor is read-out and displayed in short intervals. Due to the high rate of continuous downloads, you will be able quickly find the focus, after some initial practice. You should select the 1 x 1 binning mode for this focusing, although you might choose 2 x 2 binning for your final exposures.

To facilitate finding the focus, some programs offer two different numerical values: On the one hand, this is the value for the brightest pixel in the selected area (this value should be maximized); on the other hand, it is the value for FWHM (Full Width at Half Maximum = width of the distribution of a star's brightness values), which should be minimized.

If the seeing is bad, these values will strongly fluctuate from one image to the next, even though you did not change the focus. This makes it rather difficult to determine the true, best point of focus. However, do not give up too easily, because a precise focus is the essential prerequisite for successful astrophotos.

Focusing a star: Top extremely defocused, center quite focused, bottom best focus with the help of the values MaxPixel and FWHM.

Setting of Exposure Time

The next challenge is finding the correct exposure time. This is dependent upon a number of different factors such as focal ratio, brightness of the object, weather and visibility conditions, sensitivity of the astronomical CCD camera, employed filters, and transmittance of the respective optics. Therefore, it is not easy to give a specific recommendation. Just start with exposure times between 1-5 minutes and compare the results (see right box).

Make sure that the bright central areas of the object are not overexposed, i.e., they are not totally saturated. If they are, all details will, in fact, be permanently lost and cannot be reproduced through image processing. If brighter, neighboring stars in the frame are saturated at their centers, this is not so relevant. You have found the ideal exposure time when the brightest area of the object is just below the threshold of being overexposed. If in doubt, take a number of shorter exposures and add them afterwards.

The First Exposure

If everything has been prepared correctly, you can start the actual exposure. It is important, however, that you constantly check the tracking of the mount during the exposure and correct it if necessary (see next section). In any case, always take multiple exposures!

The cooling of the sensor notwithstanding, each image contains a certain percentage of noise that can be reduced by stacking several single frames. Image noise is decreased by the square root of the number of images. For example, if four images are averaged (or stacked) only half of the original noise is left; with nine averaged images, only one third is left; and with 16 averaged images only one quarter of the noise is left.

Here you can find specific tips for your first images with a CCD camera:

Tips for the First Exposures

Suitable motifs are fairly bright objects such as the Orion Nebula (M 42), the double cluster "h and chi Persei" in Perseus, the globular clusters M 3 and M 13, the Dumbbell Nebula (M 27), the Andromeda Galaxy (M 31), and the Whirlpool Galaxy (M 51).

Select exposure times that are so short that your mount can accurately track and still produce pinpoint stars without guiding. Depending upon the respective mount and focal length, this can be anywhere between 30 seconds and 2 minutes. At any rate, long enough to obtain a first deep-sky photo by adding single frames!

Guiding

Guiding is the above-mentioned check and correction of the tracking during a bulb exposure–an important requirement for an impressive and sharp astrophoto. A good, solid mount of high mechanical quality is an excellent investment, especially for a start. At a certain exposure length, every automatic tracking begins to show irregularities that need to be corrected. Guiding, in fact, becomes more important in the following cases:

▸ The periodic error or the imprecision of the tracking is more pronounced
▸ The employed focal length is longer
▸ The pixels of the camera are smaller
▸ The declination of the image field comes close to zero (at the celestial equator)

If you would like to postpone the subject of guiding for the time being, learn the maximum exposure time your telescope and camera combination allows without the stars trailing. Then, take many pictures with this exposure time and add them later.

However, if you want to try your hand at long exposures, the following guiding methods are available:

▸ A second telescope (guide scope) can be mounted on your imaging telescope, select a reticle eyepiece–preferably an illuminated one–and center a "guide star" in it. During the exposure you ensure that the guide star remains centered, otherwise, you make corrections using the push buttons of the mount's hand controller to navigate it back to its center position. If the guide scope is set up with tube clamps, this allows for the search of a guide star independently from the main telescope.
▸ As an alternative to working with a guide scope, you can employ an off-axis guider, in which a small portion from the edge of the image field is deflected by 90 degrees (see page 102), and which can be used to search

for a guide star. However, an off-axis guider severely limits the selection of a guide star, and often renders a distorted star image far off the optical axis. In addition, it often provides a rather uncomfortable viewing position, because it might have to be turned around the optical axis in order to find a suitable guide star.

In both cases, you can guide either manually or with an autoguider. An autoguider is a digital camera with an image sensor, on which the selected guide star is displayed. The control software reads-out the sensor at intervals of a few seconds and analyzes the position of the star. If there are divergences, the software controls the mount with minute movements so that the star returns to its original position. The interaction between the mount's drive, as well as the software and its respective parameters needs to be "trained" before each imaging night or after each motif change (rotation of the camera, change of declination). The software needs to "know", for example, in which direction the star is moved with which control commands and at what speed. You can test this beforehand at dusk, so that you will not lose valuable observation time.

For autoguiding, separate autoguiders or guiding heads are available. Some camera models even use the imaging sensor itself. Other CCD cameras have a built-in second sensor. With these guiders you might be required to rotate the camera in order to find an appropriate guide star. If you are using external guiders, you need to make sure that there is a secure connection between the main telescope and the guide scope.

Autoguider SBIG ST-4 with control box and CCD head. This autoguider can be operated without a computer just like its successor SBIG ST-V.

Taking Color Images

If you are using a monochrome astronomical CCD camera, you need to take additional exposures through red, green, and blue filters if you want a color image as the final result. A color filter wheel or a filter slider between the focuser and the camera are both well suited for this. Ideally, the filter wheel is motor-driven and controlled contact-free via the computer.

There are filter sets available that–apart from a red, green, and blue filter–also include a clear filter or a UV blocking filter, which is parfocal to the color filters. This means, that the focus for all filters is identical, making them easier to work with. Otherwise, you would have to optimize the focus after each filter change. At any rate, you should take several exposures (not just one) through the color filters, as well. Thus, you can also reduce the noise through averaging. For color images, red-, green-, and blue-filtered exposures are actually sufficient.

The result is a so-called RGB image. A shrewd way to save exposure time is to take a monochrome image without a filter (or with the clear filter or UV filter) with the maximum resolution (1 x 1 binning), and to image the color frames for red, green, and blue using the 2 x 2 or 3 x 3 binning mode. In the binned mode, the camera has a higher sensitivity; therefore, the corresponding exposure times with the color filters are shorter. If you later combine the high-resolution monochrome image with the RGB image to produce a final color image, the lower resolution of the color channels is almost indiscernible. This method is referred to as the LRGB technique.

Save Images

Astronomical CCD cameras do not have an internal memory. Each image must be saved to the hard drive of the computer directly after the exposure. The data transfer is done via the parallel port or the USB port. The latter does have an advantage though, due to its higher data transfer rate. Because many image files are produced for each motif it makes sense to use meaningful file names when saving the images. For the most part, images from astronomical CCD cameras are saved in the Flexible Image Transport System (FITS) format (ending .FIT or .FTS) (see page 119). These files not only contain the pure image data, but also details regarding the shutter speed, date and time of the exposure, as well as other information (see also right box). A less than optimal file name would be, e.g., "image1.fit". Instead, the file name "060711M31red03.fit" would be more meaningful, as it contains the date (July 11, 2006), the motif (M 31), the employed filter (red), and the number of the red exposure (third).

Calibration Images

All astronomical CCD cameras supply the genuine, unmodified read-out data of the sensor.

Tips and Tricks

Short focal lengths for the start: For a successful start, short focal lengths up to 1000 mm at most are well suited.

Balance telescope: The telescope should be perfectly balanced in right ascension, as well as in declination, i.e., it should not move if you open the clamps.

Gray filter for Sun/Moon: A specific solar filter is indispensable for exposures of the Sun! In addition, many CCD cameras require a grey filter for exposures of the Sun and the Moon, to avoid overexposures even with the shortest shutter speeds. Use a gray filter with such a density, that you can take short exposures without overexposing.

Review histogram: Ensure during the exposure that no large areas of the image are overexposed and washed out. A check of the histogram will quickly show this (see pages 26-27).

Never delete raw images: Always keep your original files. Perhaps you can achieve better results from these files later, when you have more experience and/or improved techniques.

On the one hand, this is desirable for astrophotos–on the other hand, this data still contains plenty of artifacts; that is, undesired information that needs to be removed through calibrating the images. For complete image calibration you need dark frames and flat field frames. If you do not want to expend that much effort at the start, you can limit the calibration to dark frames (see next section). If the dark noise of your camera is rather low, you may even get by without taking dark frames.

Dark Frames

The purpose of dark frames is to capture the thermal noise as well as the hot pixels of the camera, in order to subtract these from the actual image. Dark frames must be produced using the same exposure time and sensor temperature as your actual images, but without light reaching the sensor. When using a camera without a mechanical shutter, the telescope needs to be covered with the lid. Start the "exposure" and take at least three images per setting. If you used 2 x 2 or 3 x 3 binning for your color frames, you need separate dark frames for these as well. If you can control your camera's temperature for the sensor cooling, you can compile a library of dark frames in the course of time, which you can reuse later whenever sensor temperature, exposure time, and binning mode are identical.

The FITS Format

The FITS image file format has existed since the 1980s. The meaning of the abbreviation is Flexible Image Transport System. FITS works without data loss, like TIF and BMP.

The logic of the image files is straightforward and can easily be comprehended by humans, as well as computers. The header of each file describes in plain text what kind of image data is included and how it should be interpreted. This data can be viewed and modified with a text editor.

The FITS image format is the standard format for astronomer's worldwide.

Dark frame to capture thermal noise and hot pixels.

Flat Field Frames

Flat field frames are used to correct dust particles in the optical system that produce dark spots, the irregular light sensitivity of pixels, as well as dark corners caused by vignetting. In order to take flat field frames, you aim your telescope at an evenly illuminated area. This can be a diffusely lit wall, a white fabric that you place over the telescope opening and illuminate diffusely from the front, or the twilight sky. It is crucial for flat field frames that you leave the orientation of the camera and the focus point unchanged from your actual exposures.

Expose your flat field frames in such a way that the pixels reach 1/3, or up to 1/2 of their potential maximum saturation. Always take multiple flat field frames (a minimum of three), so that you can average them later. If you are using the twilight sky as an evenly illuminated area, switch off the motor-driven tracking of your mount, so that the stars or star trails will not appear in the same position in the single frames. Thus, they can be easily removed from the images through median combine. You need to

Flat field frame for capturing dust, pixel irregularities, and vignetting.

Left: raw image, center: dark frame subtracted, right: flat field corrected.

generate a distinct set of flat field frames for each different binning mode and filter which was used for your actual exposure.

By the way: Inferior flat field frames can substantially deteriorate the final result. In case of doubt, perform a comparative calibration without using the flat field frames.

Bias Frames

Bias frames should only contain the camera-specific value by which each pixel is charged through a bias voltage. Bias frames are generated with a zero-second exposure at the lowest possible sensor temperature. If you are using a camera without a mechanical shutter, the lid needs to be employed. Typically, you will not need bias frames, since the bias is already contained in the dark frames and is thus subtracted from the exposures during the dark frame correction. You only need bias frames if you have taken your dark frames at a different exposure time than the actual expo-

Generating a flat field frame using a lid of semi-transparent paper.

sures. Software programs such as MaxIm DL can later convert the dark frames to the required exposure time with the help of bias frames.

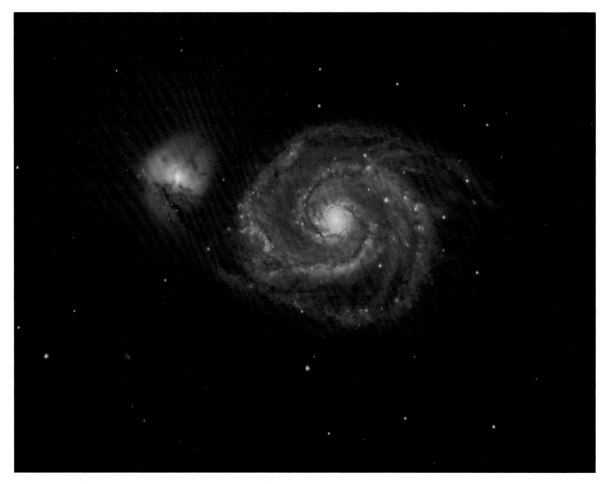

The Whirlpool Galaxy (M 51) is a popular photo motif for a CCD camera.

Processing your Astronomical CCD Camera Images

Suppose you have imaged a deep-sky object with your CCD camera; first without a filter, then again with a red, green, and blue filter, respectively. In addition, you have taken dark frames and flat field frames for the calibration. Out of this collection of images, you would now like to create a colored astrophoto.

The Data Pool

To exemplify the necessary image processing, let us assume that you imaged the Lagoon Nebula (M 8) with your CCD camera, and now have the following files available:

- ▶ Five monochrome images in full resolution (1 x 1 binning) with the file names: CCD_M8_1_1x1.fit up to CCD_M8_5_1x1.fit
- ▶ One image per color filter in half the resolution (2 x 2 binning) with the file names: CCD_Red_ 2x2.fit, CCD_Green_2x2.fit, and CCD_Blue_ 2x2.fit
- ▶ A dark frame and a flat field frame (1 x 1 binning) with the file names: CCD_Dark_1x1.fit and CCD_Flat_1x1.fit
- ▶ A dark frame and a flat field frame (2 x 2 binning) with the file names: CCD_Dark_2x2.fit and CCD_Flat_2x2.fit

The files in 1 x 1 binning mode have a size of 1152 x 854 pixels, and the ones in 2 x 2 binning mode a size of 576 x 427 pixels. It is important that you generated a separate dark frame and flat field frame for the 2 x 2 binning mode, as well.

You can download the sample data for this chapter for your own practice from http://www.astromeeting.de/astrophotography_digital.htm.

Image Processing with Astroart

The software program Astroart 3.0 is well suited for calibration and image composition; therefore, it is utilized for the examples contained here. You can find the respective website, as well as a free demo version on http://www.msb-astroart.com (see Resources page 141). The complete, newer version 4.0 can be purchased for $185.

Evaluation of Single Frames

First of all, open a monochrome image (e.g., CCD_M8_1_1x1.fit) in Astroart with the command File>Open. The software will only show part of the image's dynamic range, which can be adjusted by moving the white and black arrows on the right side of the window (see circles Image **1**).

Move the black arrow to the lower limit and the white arrow to the upper limit. The image appears darker now (Image **2**). The slider only affects the display of image data; it does not actually change the data itself.

Experiment a bit with both arrows, in order to visualize different displays of the image. Apart from the nebula and a number of stars, you can also see small, bright pixels; these are so-called "hot pixels". They will disappear after completing the image calibration with the dark frame.

If you move the white arrow down, all brightness levels above the arrow will be shown as pure white (Image **3**). The central area of the nebula now appears to be overexposed, whereas the noise–the grainy structure that prevents the nebula from appearing "smooth"–is quite apparent in the faint border areas. Adding the images will reduce this noise.

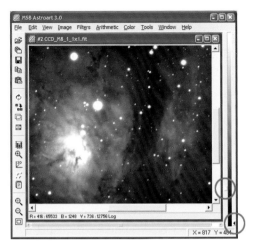

1 *Displaying a part of dynamic range of the image.*

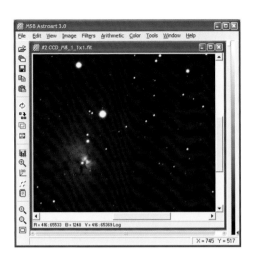

2 *Exceedingly dark display.*

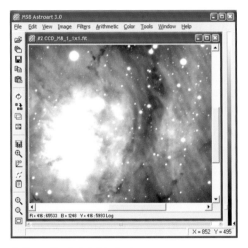

3 *Exceedingly bright display.*

The first task is to now open all five monochrome images, CCD_M8_1_1x1. fit through CCD_M8_5_1x1.fit, to check if they are usable. Images showing tracking errors, such as trailing stars, must be excluded from the adding of the images. You can either delete them or move them to a different folder.

First, open the dark frame (CCD_Dark_1x1.fit) and then open the flat field frame (CCD_Flat_1x1.fit). The dark frame contains the dark noise (mostly due to thermal current) and the hot pixels (Image **4**).

The hot pixels are only distinguishable through the extreme position of the arrows on the right side. The dots in the image are not stars, since the dark frame was taken with the lens cap on! The flat field frame clearly displays the vignetting, caused by the uneven illumination of the optics (Image **5**). This brightness gradient is only visible, because a small part of the brightness range is shown highly stretched (note the arrows!).

4 *Dark frame.* **5** *Flat field frame.*

Calibration and Addition of the Monochrome Images

As a first step, you will calibrate and add the five monochrome images. Close all other file windows. Astroart features a very powerful tool that completes the calibration, as well as the addition of single frames, in just one step. For this purpose, select Tools>Preprocessing.

From the top left corner, select the drive and the respective folder where your images are stored. The files will then be shown as a list in the bottom left corner. Now, use the cursor to drag-and-drop the files to the respective areas on the right side, thus moving CCD_Flat_1x1.fit to the box *Flat Fields*; CCD_Dark_1x1.fit is moved to the box *Dark Frames*; and the five actual exposures are moved to the box *Images*.

If you have inadvertently moved a file to the wrong box, simply click on this file with the right mouse button and select *Delete* from the context menu. Now, select the tab *Options* in the same dialog window.

Here you need to ensure that *Average* is selected for *Images*. This means that the five images are to be averaged. Deselect *Confirm each image* under *Options*. Select the remaining settings as shown in the screenshot of the dialog window. Are you sure everything is correctly set? If yes, start by clicking the *OK* button.

Attention: This procedure will only work if the images are congruent. If the five RAW images are misaligned or twisted, you will need to activate the option *Auto alignment*, as well.

The result is a single, new image, largely free of noise and hot pixels (Image **6**).

To save this monochrome image under a meaningful name, select File>Save FITS.

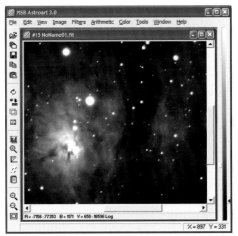

6 *Calibrated and averaged B/W.*

Here "CCD" indicates the type of camera with which the image was taken, "M8" the object Lagoon Nebula, "Lum" the luminance, and "SUM(5)" conveys that it is the sum of five single frames.

Calibration and Scaling of the Filtered Images

The same procedure will now be applied to the color frames. This is the dialog window for red:

Make sure that the matching binning mode is selected for both the dark and flat field frames. The result of the calibration is shown in Image **7**. Since the image was taken with lower resolution, it needs to be scaled to the size of the luminance frame. Select Image>Resize for the applicable dialog window:

7 *Calibrated red frame*

Enter "200" (i.e., twice the image size) in the X and Y percentage fields in the bottom right corner, and confirm with *OK*. Astroart now interpolates the image to twice its size. The image loses some sharpness in this process, but this is not critical for the color channels (see Image **8**).

8 *Red frame; size doubled through interpolation.*

To remove small defects that are still visible despite the calibration, select the menu item Filters>Median> Median N×N, and choose "3" as cell size.

The resulting image appears smoother, although at the expense of sharpness. But, as mentioned before, this is not really relevant for the color channels. However, the median filter should not be applied to the luminance channel, since it generates the sharpness for the final image.

Save the first color frame under a meaningful name and repeat the procedure for the green and blue frames accordingly.

In the file name, Red indicates red, and SUM(1) signifies that only one frame was used for the red channel.

Accurate Alignment of the Color Frames

You now have four calibrated and congruent image files of the same size: CCD_M8_Lum_SUM(5).fit (luminance channel, sum of five exposures), CCD_M8_Red_SUM(1).fit (red channel), CCD_M8_Green_SUM(1).fit (green channel), and CCD_M8_Blue_SUM(1).fit (blue channel). Before you perform the color composition, you should ensure the accurate alignment of the files. Open all four files simultaneously in Astroart and arrange the windows with the option Window>Tile (Image **9**).

9 *Alignment of color frames.*

If you do not have to worry about image field rotation caused by a mount that was not accurately polar-aligned, alignment on a single star is sufficient. For this purpose, click on the file window CCD_M8_Red_SUM(1). fit. Then, move the mouse over a brighter star and check in the status bar the respective coordinates for this star (Image **10**).

10 *Selecting a reference star.*

In this example, a brighter star above the center of the nebula was chosen. The status bar displays the coordinates X = 482; Y = 489. You need to memorize (or note) these coordinates, for now you select the option Image>Align.

A dialog window opens, in which you need to define which image should be used as "reference". Select CCD_M8_Lum_ SUM(5).fit from the luminance channel for this.

After confirming by clicking *OK*, the next dialog window is opened (see top right). Select *One star* as method, and enter the memorized coordinates under X1 and Y1. R1 indicates the radius in which the program will look for the reference star. Just accept the default value of 20 pixels for this.

After clicking *OK* you might notice that the red frame was moved a fraction to achieve congruence with the luminance image. Align the green and blue channels in the same way, always selecting the luminance image as reference. In case of image field rotation, you need to select the *Two stars* method, preferably selecting stars distant from the center, in opposite corners.

Composition of the Color Image

Now these four images will be put together to create an LRGB image (i.e., a finished color image). Start by selecting Color>Trichromy, RGB, CMY. The following dialog window is shown:

By clicking on the buttons [red], [green], and [blue] the corresponding files are selected. You can define the weighting for each color behind the respective buttons. This is dependent upon the spectral sensitivity of the employed camera and needs to be identified for each camera model. For the present example, enter 0.6 for green and 0.8 for blue, and leave the value for red at 1.0. This means that the camera has its highest sensitivity in green and the lowest sensitivity in red.

Confirm by clicking *OK*. Accept the subsequent dialog window *Color balance* without any changes. To begin with, you receive an RGB image (Image **11**). For the final result you blend in the luminance channel. For this purpose, select *LRGB Synthesis*. In the small dialog window you can define your luminance image.

11 *Composite RGB image.*

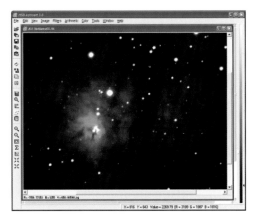

Select CCD_M8_Lum_SUM(5).fit and confirm with *OK*. The color image now appears much sharper (Image **12**).

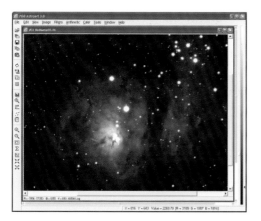

12 Composite LRGB image.

Sharpen

Next, use the command Filters>Unsharp mask with the following parameters, and do not forget to mark the checkbox for *Adaptive*.

Now the image processsing is almost done (Image **13**).

13 Sharpened LRGB image.

At this point, I propose to quit the processing in Astroart, and to save the image in a lossless file format. The command is File>Export>Windows Bitmap (see dialog window top right). Save your work with a meaningful file name, for example, CCD_M8_LRGB.BMP. Unfortunately, Astroart cannot just export the color image in 16-bit TIF format; therefore, the workaround with the bitmap format is the easier solution.

However, an early conversion of the LRGB image to an 8-bit image is a drawback.

Fine-Tuning in Photoshop

You now open the exported BMP file in Photoshop and perform some final fine-tuning according to your personal taste. I have used, for example, the menu item Image>Adjustments>Curves to slightly brighten up the darker areas of the nebula, without causing the center to become a shapeless white area.

For this, you set the curve as shown in the dialog window on the left. This step, along with minimal color corrections, produces the final result of the Lagoon Nebula (Image **14**).

Tip

Calibrated monochrome images in the FITS format can be further processed directly in Photoshop (from version CS on). For this, you can use a plug-in that is available free of charge on the internet at http://www.spacetelescope.org/projects/fits_liberator/.

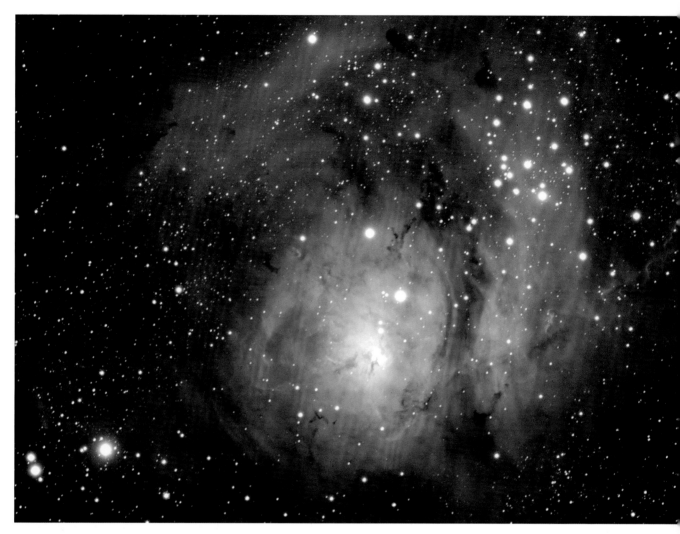

14 *Final processed image.*

Conclusion

Clear Skies!

Don't give up if your first photos are not perfect. What is true for all other disciplines also applies to astrophotography: practice makes perfect.

Enjoy it and – clear skies!

Astrophotography is Fun

If you have made it to this part of the book, you have probably already taken your first astrophotos. Then you certainly realize that even with all the available modern digital technology, virtually all images take some time and effort. It is not without cause that astrophotography is considered one of the most challenging sectors in the field of photography. You shouldn't expect to achieve top results during the first night. However, as you continue to strive to produce excellent photos, the road to success and the visible progress on this road are exciting, as well. First and foremost, always remember that your hobby should bring you pleasure.

The photos from professionals, taken with gigantic telescopes, space telescopes, or even from spacecrafts, cannot be a measure for hobby astronomers. Rather, the point for the hobbyist is to produce the most beautiful images with the equipment you have–and that can certainly be a lot! Only after some experience, and if you feel you have reached a plateau of quality and proficiency with your own equipment, it may be worthwhile to invest in a superior telescope or a more powerful camera.

You can compare astrophotography with learning how to play a musical instrument: A precious Stradivarius instrument does not automatically help the violin student play better music. When shopping for equipment, be wary of ads that promise an ideal world for the astrophotographer. The devil is in the details: Even when you have taken every precaution, you may still stumble upon problems such as the driver of the camera cannot be installed, a guider cable will not fit into the plug of the mount, or you may trip over the tripod leg during the first exposure. And even if all the technology works, the sudden appearance of clouds could abruptly terminate your photo session. Therefore, you should regard each successful astrophoto as a reward for meeting numerous technical and organizational challenges, and don't forget the ounce of luck for good weather. It is not the quantity that matters, because just one good astrophoto after a whole night of imaging can be a satisfying rate of return.

Presentation and Data Backup

Do not hide your best photos or put them in "final storage" in a folder on your hard disk. Get high-quality printouts on photographic paper, or purchase a photo printer yourself. Even if modern images are taken with digital cameras and can easily be viewed on the monitor, the satisfaction of holding a beautiful photograph in one's hands with a self-imaged motif, remains unchanged. Furthermore, the impressive effect of a printed photo is reinforced if you present it in a frame with a proper mat!

If the images are to be presented in a rather scientific setting, it is desirable to include a few details as text on the images, such as the name of the object and important imaging parameters. With a good image processing tool like Photoshop, this can quickly be accomplished. Just ensure when you save it that you are not overwriting your original image.

Backing up your image files is of utmost importance. If you save your image files on only one hard disk, you run the risk that they can be irretrievably lost in case of hard disk damage. Thus, backup you data in a second storage location, which should also be spatially separated. In this way, you will still have a backup copy if your computer is damaged or lost.

May you enjoy many clear and steady nights!

Appendix

Digital Cameras for Astrophotography

A simple compact camera will allow you to take nice scenic shots. With a digital single lens reflex (DSLR) camera, you can furthermore capture halo effects, as well as Northern Lights, and take impressive images of the Sun, the Moon, and bright nebulae. A webcam is the ideal camera for shooting planets, whereas an astronomical CCD camera can provide amazing images of star clusters, nebulae, and galaxies.

Application Areas of Digital Cameras in Astrophotography

	Compact camera	Webcam	DSLR	Astronomical CCD camera
Scenic shots at dawn or dusk	+	– –	++	– –
Star trails	+/-	– –	+	–
Wide field exposures (constellations, Milky Way)	+/-	– –	+	+/-
Sun and Moon, incl. eclipses	+	+	++	+
Planets	– –	++	–	–
Special events (e.g., Meteor showers, Northern Lights, Halo effects)	+	– –	++	–
Deep-sky objects, large and bright	–		+	++
Deep-sky objects, small and faint	– –	– –	+/-	++

Legend: very well suited ++ + +/- – – – not suited.

The Correct Angle of View

Focal Length	Angle of View	Frame Filling Motif
Webcam PHILIPS SPC900NC (Sensor size: 4.6 × 3.97 mm)		
200 mm	0.8 × 1.1 degree	Full Moon, Sun
400 mm	0.4 × 0.5 degree	Crescent Moon
1000 mm	9.5 × 12.7' *	Mare Imbrium on the Moon
1500 mm	6.3 × 8.4'	Mare Serenitatis on the Moon
2000 mm	4.7 × 6.3'	Mare Crisium
3000 mm	3.2 × 4.2'	Crater triangle Archimedes, Aristillus, Autolycus
5000 mm	1.9 × 2.5'	Crater Clavius
DSLR Canon EOS Digital Rebel XT/20D (Sensor size: 22.5 × 15 mm)		
100 mm	13 × 8.5 degree	Constellation Lyra
200 mm	6.4 × 4.3 degree	North America and Pelican Nebula in Cygnus
500 mm	2.6 × 1.7 degree	Orion Nebula complex (M 42/M 43)
1000 mm	1.3 × 0.9 degree	Pleiades (M 45), star cluster in the constellation Taurus
1500 mm	0.9 × 0.6 degree	Full Moon, Sun
2000 mm	0.6 × 0.4 degree	Crescent Moon, thin crescent Moon
3000 mm	0.4 × 0.3 degree	Trifid Nebula (M 20) in the constellation Sagittarius
CCD Camera Starlight Xpress SXV-M7C (Sensor size: 6.5 × 4.8 mm)		
100 mm	2.8 × 3.7 degree	Andromeda Galaxy (M 31)
200 mm	1.4 × 1.9 degree	Pleiades (M 45), star cluster in the constellation Taurus
500 mm	0.6 × 0.8 degree	Full Moon, Sun
1000 mm	0.3 × 0.4 degree	Spiral galaxy M 81 in the constellation Ursa Major
1500 mm	0.2 × 0.3 degree	Spiral galaxy M 51 in the constellation Canes Venatici
2000 mm	0.15 × 0.2 degree	Spiral galaxy M 82 in the constellation Ursa Major
3000 mm	0.1 × 0.12 degree	Ring Nebula (M 57) in the constellation Lyra
CCD Camera SBIG STL-1100 (Sensor size: 36 × 24.7 mm)		
100 mm	13.7 × 20.5 degree	Constellation Cassiopeia
200 mm	6.9 × 10.3 degree	Hyades, star cluster in Taurus
500 mm	2.8 × 4.1 degree	Andromeda Galaxy (M 31)
1000 mm	1.4 × 2.1 degree	Orion Nebula complex (M 42/M 43)
1500 mm	0.9 × 1.4 degree	Galaxy in the constellation Triangulum (M 33)
2000 mm	0.7 × 1.0 degree	Full Moon, Sun
3000 mm	0.5 × 0.7 degree	Globular cluster in Hercules (M 13)

** 1 arc minute (') = 1/60 degree. See section "The Correct Angle of View" on pages 8-11.*

Resources: Web Links, Addresses; Further Reading

Image Processing Software

MaxIm DL / DSLR, Camera Control/Image Processing Software
http://www.cyanogen.com

Astroart, Camera Control/Image Processing Software
http://www.msb-astroart.com

Iris Image Processing
http://www.astrosurf.com/buil/us/iris/iris.htm

ImagesPlus, Camera Control/Image Processing Software for DSLR's
http://www.mlunsold.com

DSLRFocus, Camera Control Software for DSLR's, Focussing Tool
http://www.dslrfocus.com

IrfanView, Freeware Graphic Viewer
http://www.irfanview.com

Adobe Photoshop, Image Processing Software
http://www.adobe.com/products/photoshop/photoshop/

Microsoft GIF-Animator, Tool to produce animated GIF files
http://ms-gif-animator.en.softonic.com

FITS-Liberator Photoshop-Plugin, Freeware Tool for Photoshop to open file in FITS
format
http://www.spacetelescope.org/projects/fits_liberator/

NeatImage, Tool to reduce the image noise
http://www.neatimage.com

PaintShop Pro, Image Processing Software
http://www.corel.com

GIMP, GNU Image Manipulation Program, Freely distributed Image Processing Software
http://www.gimp.org

Registar, Tool for image registration (astrophotography)
http://www.aurigaimaging.com

Registax, Freeware tool to register and stack images from Webcams, Video cameras and DSLR's
http://registax.astronomy.net

K3CCDTools, Camera Control Software for Webcams and Video cameras
http://www.pk3.org/Astro/index.htm?k3ccdtools.htm

VirtualDub, A video capture/processing utility
http://www.virtualdub.org

TheSky, Astronomy Software, Telescope Control and more
http://www.bisque.com/Products/TheSky6/

Guide, Astronomy Software
http://www.projectpluto.com

Starry Night, Astronomy Software
http://www.starrynight.com

Cartes du Ciel, Free Astronomy Software
http://www.stargazing.net/astropc/index.html

Virtual Moon Atlas, Free Map of the Moon
http://www.astrosurf.com/avl/UK_index.html

CCD Calc, Online tool for calculating the Field of View
http://www.newastro.com/newastro/downloads/ccdCalcFree.htm
http://www.newastro.com/newastro/book_new/camera_app.asp

Digiscoping Calculator, Online tool for calculating parameter in digital photography
http://www.jayandwanda.com/digiscope/digiscope_calc.html

NiteView, Tool to change the Windows screen to night vision
http://www.astro.ufl.edu/~oliver/niteview

Satellite Predictions

http://www.heavens-above.com

http://www.calsky.com/cs.cgi?&lang=en

Astronomy Links

Website of the author
http://www.astromeeting.de

Support page for readers of this book
http://www.astromeeting.de/astrophotography_digital.htm

Cloudynights (with forums)
http://www.cloudynights.com

Astromart (with forums)
http://www.astromart.com

Yahoo Forums
http://groups.yahoo.com

Radioshack Digital Photography Glossary
http://support.radioshack.com/support_tutorials/audio_video/digvid-glossary.htm

Digital Cameras

Canon, manufacturer of DSLR- and Digital Compact Cameras
http://www.canonusa.com

Nikon, manufacturer of DSLR- and Digital Compact Cameras
http://www.nikonusa.com

Olympus, manufacturer of DSLR- and Digital Compact Cameras
http://www.olympusamerica.com

Pentax, manufacturer of DSLR- and Digital Compact Cameras
http://www.pentaximaging.com

SBIG, Santa Barbara Instruments Group, manufacturer of Astronomical CCD Cameras
http://www.sbig.com

Apogee Instruments, manufacturer of Astronomical CCD Cameras
http://www.ccd.com

Starlight Xpress, manufacturer of Astronomical CCD Cameras
http://www.starlight-xpress.co.uk

ATIK Instruments, manufacturer of Astronomical CCD Cameras
http://www.perseu.pt/atik/

Philips, manufacturer of Webcams
http://www.usa.philips.com

Imagingsource, manufacturer of Digital Video Cameras
http://www.theimagingsource.com/en/products/

Lumenera, manufacturer of Digital Video Cameras
http://www.lumenera.com

Dealer and Manufacturers of Telescopes and Photographic Accessories

Astro-Physics
http://www.astro-physics.com

Adirondack Video Astronomy
http://www.astrovid.com

Meade
http://www.meade.com

Celestron
http://www.celestron.com

Starizona
http://starizona.com

Anacortes Telescopes and Wild Bird
http://www.buytelescopes.com

Baader Planetarium, Germany
http://www.baader-planetarium.de

Hutech Corporation
http://www.sciencecenter.net/hutech/

Telescopes and Binoculars
http://www.telescopes.com

Televue Optics
http://www.televue.com

William Optics
http://www.williamoptics.com

Losmandy
http://www.losmandy.com/

Vixen
http://www.vixenamerica.com

Takahashi
http://takahashiamerica.com

TEC – Telescope Engineering Company
http://www.telescopengineering.com

TMB Optical
http://www.tmboptical.com

Books, CD-ROM's and DVD's

Making Every Pixel Count, Instructional DVD Videos by Adam Block
http://www.caelumobservatory.com/video/dvd.shtml

The New CCD Astronomy by Ron Wodaski

The NewAstro Zone System for Astro Imaging, Ron Wodaski
http://www.newastro.com/newastro/default.asp

A Year in the Life of the Universe by Robert Gendler
http://www.robgendlerastropics.com/Cover.html

Handbook of Astronomical Image Processing by Richard Berry and James Burnell
http://www.willbell.com/aip/index.htm

Introduction To Digital Astrophotography: Imaging The Universe With A Digital
Camera by Robert Reeves
ISBN-10: 0943396832, ISBN-13: 978-0943396835

Digital SLR Astrophotography by Michael A. Covington
ISBN-10: 0521700817, ISBN-13: 978-0521700818

A Guide to Astrophotography with Digital SLR Cameras by Jerry Lodriguss
(CD-ROM)
ISBN-10: 0972973753, ISBN-13: 978-0972973755

Photoshop for Astrophotographers (CD-ROM) by Jerry Lodriguss
ISBN-10: 0972973737, ISBN-13: 978-0972973731

Astrophotography for the Amateur by Michael A. Covington
ISBN-10: 0521627400, ISBN-13: 978-0521627405

Magazines

Sky & Telescope
http://www.skyandtelescope.com/

Astronomy
http://www.astronomy.com

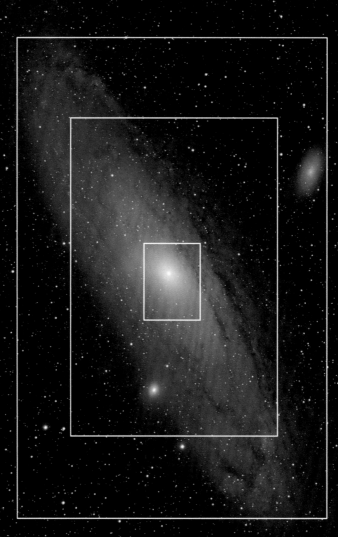

Field-of-view comparison at 750mm focal length, from the inside to the outside:
Webcam PHILIPS SPC900NC (Sensor size: 4.6 ×3.97 mm),
Astronomical CCD camera SBIG ST-10 (Sensor size: 14.9 × 10 mm),
Digital SLR Canon EOS Digital Rebel XT/20D (Sensor size: 22.5 × 15 mm),
Digital SLR Canon 5D (full format sensor: 24 × 36 mm),

Object: Andromeda Galaxy (M 31)

Glossary

afocal photography
Literal translation: photography "without a focal point." In astrophotography, holding the camera with the attached lens over the eyepiece to take a picture. There is a parallel optical path without a focal point between the camera and the eyepiece.

autoguider
A specialized device used in astrophotography to check the tracking and make corrections, if necessary, so that the stars are pinpoint and sharp. The autoguider uses its own image sensor to constantly check the position of the star that is displayed on it.

Barlow lens
A lens system with negative optical power, which increases the effective focal length of a telescope. Available are models with varying magnification factors from 1.4 to 5. The focal ratio changes accordingly.

binning
Combining the charges of several adjacent pixels. This is done to increase the sensitivity in low light situations. These combined pixels are represented by a single, larger pixel known as a super pixel. *1 x 1 binning* uses the value from a single pixel. *2 x 2 binning* combines the charges of four pixels located next to each other in a 2 x 2 array as a single super pixel. It is four times more sensitive than the single pixel, but resolution is also cut in half.

CCD
Technology for camera sensors employed today in astronomical CCD cameras as well as some webcams. Abbreviation for "charge-coupled device."

CMOS
Sensor technology that is newer and cheaper than CCD, mostly employed in digital cameras for everyday use. Abbreviation for "Complementary metal-oxide-semiconductor."

color saturation

One of the attributes of color, related to the *intensity* of a specific *hue*. When a color is less saturated, it generally has more gray or white in it. If it is completely unsaturated (i.e., saturation = 0), then the color is gray. Colors with low saturation usually look washed out or faint in color. Intensity also relates to the purity of a color.

coma

A type of lens aberration. The defect produces a bright spot with a glowing, diffuse, comet-like tail. Coma is caused when the light rays passing through the lens do not focus at the same point.

coma corrector

In particular, Newtonian reflecting telescopes suffer from coma off the optical axis. A coma corrector is a lens system that reduces or corrects this aberration.

deep-sky objects

Deep-sky objects are all objects outside our solar system such as, star clusters, gas and dust nebula, galaxies, double stars, planetary nebula, and supernova remnants.

declination

In the celestial equatorial coordinate system, declination denotes the north and south distance from the celestial equator. Comparable with the latitude on Earth, the declination can indicate values ranging from +90 degree (celestial north pole), past 0 degrees (celestial equator), to −90 degrees (celestial south pole).

effective focal length

Respective focal length when a Barlow lens, a Shapley lens, afocal photography, or eyepiece projection is used.

eyepiece

A lens system that works like a magnifying glass, and with which the image generated by the objective can be viewed magnified on the focal plane of the telescope. The focal length of the eyepiece determines the effective magnification.

eyepiece projection

Magnification of the focal plane image through projection into the camera body, whereby the eyepiece is used as a projection objective.

focal length

The distance between the objective, a lens or a mirror and the (focal) point, in which collimated light is focused by the optics. For astronomical objects (an "infinite" distance away) the focal plane is also located at the distance of the focal length.

gamma value

A correction applied to digital imaging devices to correct their inherent nonlinearity to a linear function. This correction is needed to ensure that digital displays, such as CRTs and computer monitors, display the correct brightness of an image. Gamma is used for the most basic form of color management of a display. Each color (red, green, and blue) will have its own gamma correction to provide a linear output. Not to be confused with the mathematical function *gamma*. In film photography, *gamma function* refers to the straight-line portion of a film's characteristic curve.

guiding

Checking and correcting the tracking during a bulb exposure. Some CCD cameras can guide themselves; otherwise, it can be done with a guide scope or with an off-axis guider. In the latter cases, you can either guide manually with a reticle eyepiece or with the help of an automated autoguider.

guide scope

A telescope mounted parallel to the main telescope, to check the tracking during a longer exposure.

hot pixel

Each pixel is made up of a red, green, and blue (RGB) element. On occasion, in digital image sensors as well as in LCD monitors, one or more of these elements will adhere permanently. Then, when images (or the monitor) are viewed, there is a red, green, or blue dot in the same location on every image. As cameras age, they will sometimes develop more hot pixels over time. Depending on the brightness or darkness of an image, the hot pixels will be more or less obvious. At the present time, there is no real cure for a hot pixel except to retouch the images. Some software programs, such as Apple's Aperture and Adobe Photoshop Lightroom, have a feature enabling the user to retouch one image and then apply the corrections to all images, greatly speeding up the retouching task.

noise

The undesired data parts in raw images. One part of it is model-specific. This consists mostly of the thermal noise and the readout noise. The thermal noise is higher if the temperature and exposure time are increased. It

can be reduced by cooling the sensor. Subtracting dark frames can largely eliminate thermal noise as well as readout noise.

objective

The optical system of a telescope, which generates a real image of the sky area. This image can be viewed magnified through an eyepiece (visual observation) or recorded by an image sensor (astrophotography). Refractors have an objective consisting of several lenses, reflectors are using one or more mirrors, and catadioptric systems contain both lenses and mirrors. In photography, the objective (or lens) is the image-forming optical system, as well.

off-axis-guider

Is placed between the telescope and the camera, and contains a small mirror far off the optical axis, that directs the light from a star out of the device in a 90 degree angle. Without affecting the exposure, the star can thus be monitored for guiding purposes.

parfocal

Denotes "identical focal position." If you have an eyepiece that is parfocal to your camera, you can visually focus with it, then replace the eyepiece with the camera, and thus are already close to the ideal focus point.

polar alignment

The precise setup of an equatorial telescope mount. The right ascension axis (i.e., polar axis) of the mount needs to be aligned exactly with the celestial pole in order to avoid image field rotation and resulting in trailing stars during long exposures.

prime focus photography

In prime focus photography, the camera's sensor is placed in the focal plane of the telescope, the focal length then equals the focal length of the telescope.

RAW image

An image-storage format that stores the unprocessed electrical signals from the sensor in a unique format. RAW is often thought of as a digital equivalent of a negative. The RAW format is usually different for each camera. The advantage of the RAW format is that many decisions, such as on white balance or color temperature, can be made by the photographer later and processed in the computer rather than in the camera.

readout amplification

The stored analog data of the imaging sensor is readout and amplified after the exposure by the A/D converter. Changing the sensitivity (ISO) of a digital camera determines the degree of amplification.

read-out register

A part of a CCD in which the charges from the photosites are accumulated row by row. The read-out register reads an entire row at a time on the CCD. The value from the read-out register is then sent to an *output amplifier* and an *analog-to-digital converter* before being output.

resolution

In photography the obtainable angular resolution, mostly depending upon the resolving power of the employed optics. However, only if the imaging sensor has correspondingly small pixels, can this resolving power actually be utilized. Therefore, cameras with sensors with smaller pixels have a higher (spatial) resolution than models with larger pixels. In colloquial use resolution is often referred to as the total number of pixels of a digital camera. This is not compliant with the above definition. However, if you consider identical angles of view–independent of the sensor size–then a 10 megapixel camera has in fact a higher resolution than a 6 megapixel camera, if the employed imaging optics are not a limiting factor.

right ascension

In the celestial equatorial coordinate system, right ascension denotes the distance to the vernal equinox point, comparable to the terrestrial longitude. However, it is not measured in degrees but in hours (h), minutes (m), and seconds (s). Right ascension indicates the value 0h 00m 00s for the vernal equinox point and increases eastward.

seeing

Level of air turbulence. If the seeing is bad, the stars are twinkling heavily, move back and forth in the eyepiece, and appear unfocused or distorted in certain moments. For long exposures with long focal lengths, a night with good seeing (i.e., calm and constant star images) is more suitable. This term should not be confused with transparency (clarity of the atmosphere).

sensor

A detector that has a multitude of light sensitive pixels and therefore can record a two dimensional image. Currently there are two technologies (CCD and CMOS), both of which are used in astrophotography. Incident light in the form of photons is turned into electrons. After the exposure the number of electrons per pixel are measured and displayed as brightness value.

Shapley lens

A lens system with positive optical power that decreases the effective focal length of a telescope. Depending upon the reducer, different factors from 0.8 times to 0.3 times are feasible. The focal ratio changes accordingly.

solar filter

Through a white light filter, the glaring sunlight is toned down overall, without privileging specific wavelengths. White light filters are suited for studying the photosphere with the sunspots. They are available retail as glass or film filter. Hydrogen-alpha filter only transmit the light of the singly ionized hydrogen. H-alpha filter for observing the chromosphere of the Sun have a complex design, because only a small part of spectrum is selected. Other H-alpha filters with less intricate designs, are available for photographing hydrogen nebulae, but should never be employed for solar observations.

tracking

On an equatorial mount the motor-drive for the right ascension, which ensures that the telescope will follow the rotation of the sky and thus allows observing or photographing an object for any length of time.

white balance

A feature of digital cameras, to cope with different light situations. For example, daylight has fewer yellow lightwaves than a typical incandescent light bulb. In order to display an object as appearing white in either lighting condition, the camera performs a white balance. Under certain circumstances the manual setting might be better.

Imaging Data of the Astrophotos

Page 1: Nebula surrounding Merope, a star from the Pleiades, 340 mm f/9, SBIG STL 11000, Luminance: 14 x 3 min (1 x 1 binning), RGB: 14 x 3 min (2 x 2 binning) per color

Page 5: top left: Star trails, in the foreground Kitt Peak National Observatory, Arizona, USA, 17 mm f/4.5, Canon EOS 20D @ ISO 800, approx. 20 min

Page 5: top right: Area around the Flaming Star Nebula in Auriga, 105 mm f/6, SBIG STL 11000, Luminance: 6 x 15 min (1 x 1 binning), R (2×), G (1×), B (2×): 10 min (2 x 2 binning) per color frame

Page 13: Crescent Moon, evening twilight, 60 mm f/5.6, Canon EOS 20D @ ISO 200, 3 sec

Page 27: Moon, f/ 4.8, Nikon Coolpix 5000 afocal through spotting scope, 1/90 sec, automatic mode with manual exposure correction by –1 step

Page 36: left: Venus, 10" @ f/46, Philips ToUcam 740k, 2 min AVI file, 1/1000 sec

Page 36: 2nd from left: Mars, 10" @ f/36, Philips ToUcam 740k, 120 sec AVI file, 1/33 sec

Page 36: 2nd from right: Jupiter, 10" @ f/30, Philips ToUcam 740k, 75 sec AVI file, 1/25 sec
Page 36: right: Saturn, 10" @ f/29, Philips ToUcam 740k, 14 AVI files 120 sec each, 1/25 sec

Page 37: left: Sunspots, 200 mm, Philips ToUcam 740k, 9 stacked images, 1/250 sec each

Page 37: 2nd from left: Occultation Moon/Saturn : 130 mm f/8, 3 COM Webcam HomeConnect, 1/25 sec

Page 37: 2^nd^ from right: Double star Albireo, 155 mm f/7, Philips ToUcam 740k, 1/25 sec

Page 37: right: Lunar crater, 254 mm f/10, Philips ToUcam 740k, 1/25 sec

Page 51: Saturn, 10" @ f/30, Philips ToUcam 740k, 13 AVI files 20 sec each, 1/25 sec

Page 60/61: Veil Nebula, 105 mm f/6, Canon EOS 20Da @ ISO missing, 11 x 10 min

Page 63: Annular Solar Eclipse, 300 mm f/8, Canon EOS 20D @ ISO 100, 1/1000 sec per image

Page 64: top: Brocken specter, 56 mm f/11, Canon EOS 20D @ ISO 800, 1/350 sec

Page 65: Perseids in front of the Milky Way, 11 mm f/4, Canon EOS 20Da, 10 x 2 min for the background, Meteor images added

Page 73: Fragment of a circumhorizontal arc, 17 mm f/8, Canon EOS 20D @ ISO 100, 1/750 sec

Page 80: Pleiades, 105 mm f/6, Canon EOS 20Da @ ISO 800, 15 x 5 min

Page 81: Earthshine of the Moon, 150 mm f/8, Canon EOS 20Da @ ISO 400, 6 sec

Page 91: The Witch Head Nebula (IC 2118), 105 mm f/6, Canon EOS 5D@ ISO 1600, 8 x 10 min

Page 92/93: Orion Nebula (M 42): 155 mm f/7, SBIG STL 11000, 6 x 300 sec (2 x 2 binning) for each color (RGB) plus 6 x 10 sec (2 x 2 binning) for the central area

Page 94: Nebula (IC 1318) around Gamma Cygni, 105 mm f/9, SBIG STL 11000, Luminance: 6 x 15 min (1 x 1 binning), RGB: 5 x 10 min (2 x 2 binning) per color

Page 95: Double star cluster in Perseus (NGC 869/884), 155 mm f/7, SBIG STL 11000, Luminance: 14 x 300 sec (1 x 1 binning), RGB: 9 x 300 sec (1 x 1 binning) per color

Page 96: Veil Nebula region (NGC 6964/6979), 155 mm f/6, SBIG STL 11000, Luminance: 12 x 300 sec (1 x 1 binning), RGB: 6 x 300 sec (1 x 1 binning) per color

Page 97: Galaxy M 83, 155 mm f/7, SBIG STL 11000, RGB: 5 x 5 min (1 x 1 binning) per color

Page 98: Globular cluster M 13, 340 mm f/9, SBIG STL 11000, Luminance: 23 x 180 sec (1 x 1 binning), RGB: 6 x 180 sec (1 x 1 binning) per color

Page 99: Comet Machholz and the Pleiades, 300 mm f/4-5.6, SBIG STL 11000, 16 x 60 sec (2 x 2 binning) for the stars, for the comet Luminance: 6 x 60 sec (2 x 2 binning), R 90 sec, G 60 sec, B 90 sec: two pictures (3 x 3 binning) per color

Page 121: Galaxy M 51, 340 mm f/9, SBIG STL 11000, Luminance: 15 x 600 sec (1 x 1 binning), RGB: 3 x 900 sec (2 x 2 binning) per color

Page 134/135: Star Cluster NGC 2671 and emission nebulae in Vela, 105 mm f/6, SBIG STL 11000, Luminance: 6 x 10 min (1 x 1 binning), RGB: 3 x 10 min (2 x 2 binning) per color